CARVE
your own
TOTEM POLE

CARVE
your own
TOTEM
POLE

BY WAYNE HILL AND JAMES McKEE
PHOTOS BY BEV McMULLEN

The BOSTON
MILLS PRESS

A Boston Mills Press Book

Copyright © 2007 Wayne Hill and James McKee

Photographs copyright © 2007 Bev McMullen

First Printing

Library and Archives Canada Cataloguing in Publication

Hill, Wayne, 1950-
Carve your own totem pole / by Wayne Hill and James McKee ; photos by Bev McMullen.
Includes index.
 ISBN-13: 978-1-55046-466-5 (pbk.) ISBN-13: 978-1-55046-473-3 (bound)
 ISBN-10: 1-55046-466-3 (pbk.) ISBN-10: 1-55046-473-6 (bound)
1. Totem poles.
2. Indian wood-carving – Northwest Coast of North America.
I. McKee, James, 1943- II. Title.
E98.T65H45 2007 731'.7 C2007-902036-4

Publisher Cataloging-in-Publication Data (U.S.)

Hill, Wayne.
Carve your own totem pole / by Wayne Hill and James McKee ;
photos by Bev McMullen.
[132] p. : col. photos. ; cm.
Includes index.
Summary: A guidebook to the history of totem-pole carving and its West Coast native traditions, techniques and patterns; examines historic and modern tools involved, and presents ideas for carving a totem pole.
 ISBN-13: 978-1-55046-466-5 (pbk.) ISBN-13: 978-1-55046-473-3 (bound)
 ISBN-10: 1-55046-466-3 (pbk.) ISBN-10: 1-55046-473-6 (bound)
1. Totem poles – Northwest Coast of North America.
I. McKee, James. II. Title.
730.89/970711 dc22 E98.T65.H555 2007

Published by Boston Mills Press, 2007
132 Main Street, Erin, Ontario N0B 1T0
Tel: 519-833-2407 Fax: 519-833-2195

In Canada:
Distributed by Firefly Books Ltd.
66 Leek Crescent
Richmond Hill, Ontario, Canada L4B 1H1

In the United States:
Distributed by Firefly Books (U.S.) Inc.
P.O. Box 1338, Ellicott Station
Buffalo, New York 14205

Additional research and writing by Andrew Wagner-Chazalon
Design by Linda Norton-McLaren

Printed in China

The publisher gratefully acknowledges for the financial support of our publishing program the Canada Council, the Ontario Arts Council, and the Government of Canada through the Book Publishing Industry Development Program (BPIDP).

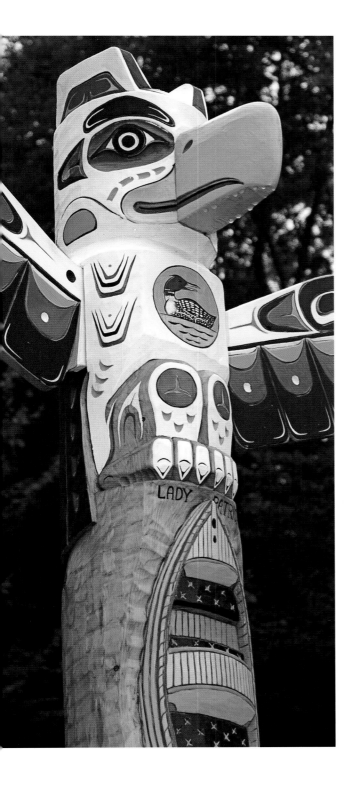

CONTENTS

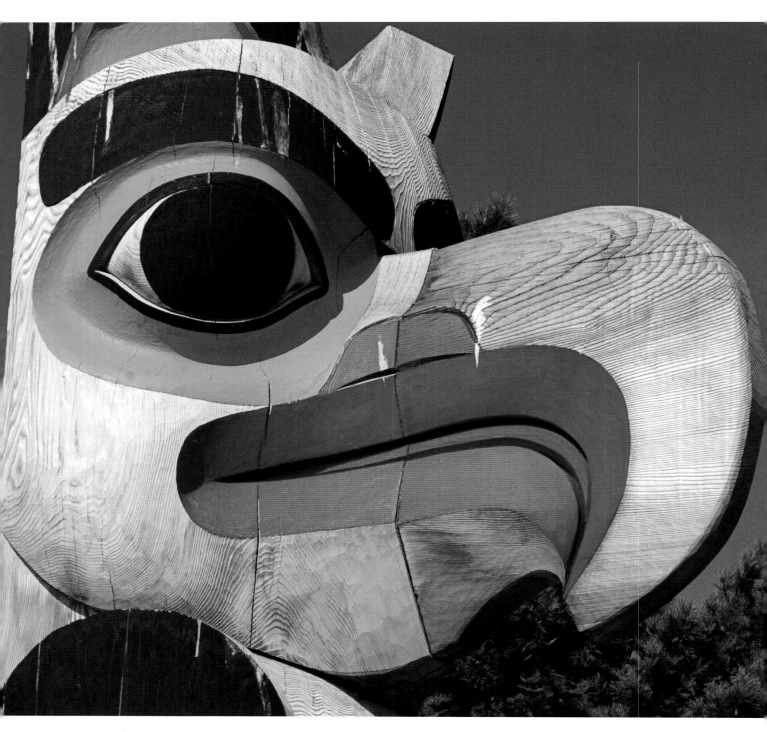

*West Coast carving is a proud
part of the North American
artistic heritage. Sites like
Kluane Wilderness Village in the
Yukon help that tradition thrive.*

Foreword

The history of Canada's earliest artists involves not the Cornelius Krieghoffs or Lucius O'Briens who were trained in the European style, but the Natives, each community with their own personal understanding as they used the natural palettes of the local areas.

The stories about the art forms from the Pacific Northwest Coast of the Americas come from an eleven-thousand-year history of the people's migration from Asia to a new landscape towards the sun, recently revealed by the retreat of the continental ice. The stories learned from the hardships experienced by the Asiatic people on arriving and occupying the new landscape by way of sea, ice, and land bridges are not recorded in the manner of documentation in the tradition of European historians. Rather, they are a result of word of mouth transmitted by generations of hunter-gatherers in search of food, shelter, and living space in territory rendered clean by the effect of advancing and melting ice masses large enough to reshape the surface of the earth itself. Each protohistoric transmission comes from the memories imprinted on the minds of the struggling travelers as they strove to recreate a way of life in a new world, knowing that it was unlikely that they would return to the place from whence they came.

There is no written record of the passage, only the carved symbols created on stone and wood by the migrants as they moved. Any modern record has to be the result of the works of scholars who found ways to interpret the symbols. The works left to us become the design forms that represent the processes of the migrating people as they expressed their souls in a developing relationship with a new and difficult landscape and the ecosystems that landscape harbored, particularly in the intertidal zone. Examples of scholarly design form are found in the works of Dr. Franz Boas and Marius Barbeau, from the Victorian era to the post-Depression era in North America. Others, like Dr. George MacDonald, have followed in increasing proliferation of sympathy towards the thoughts passed on by the symbols put down by new generations of Native people of the Pacific Northwest Coast. Dr. Boas would refer to their effort as primitive art and proceed to indicate clearly that these efforts were far from primitive. They were a long-lasting expression that required careful, sympathetic thought and constant practice. The dramatic result of this practice needs to be passed on to the future generations in North America to strengthen the understanding of the art form. The creatures that they harvested eventually were symbolized in their art forms.

In Ontario there have been very few people who have studied and followed the original West Coast styles and their strict disciplines and yet created their own totemic art. Wayne Hill is teaching West Coast carving in the summer at Sir Sandford Fleming College. Jimi McKee has been studying, carving, and painting for thirty years. They have carved over two hundred major totems and thousands of carvings including large tables and wall pieces. They are bringing to the East Coast of Canada and the United States the history of our country and it is carried on today. This can do nothing but good for our future, and I wish them well.

Peter Harvie
Haida Elder, Carver, and Teacher

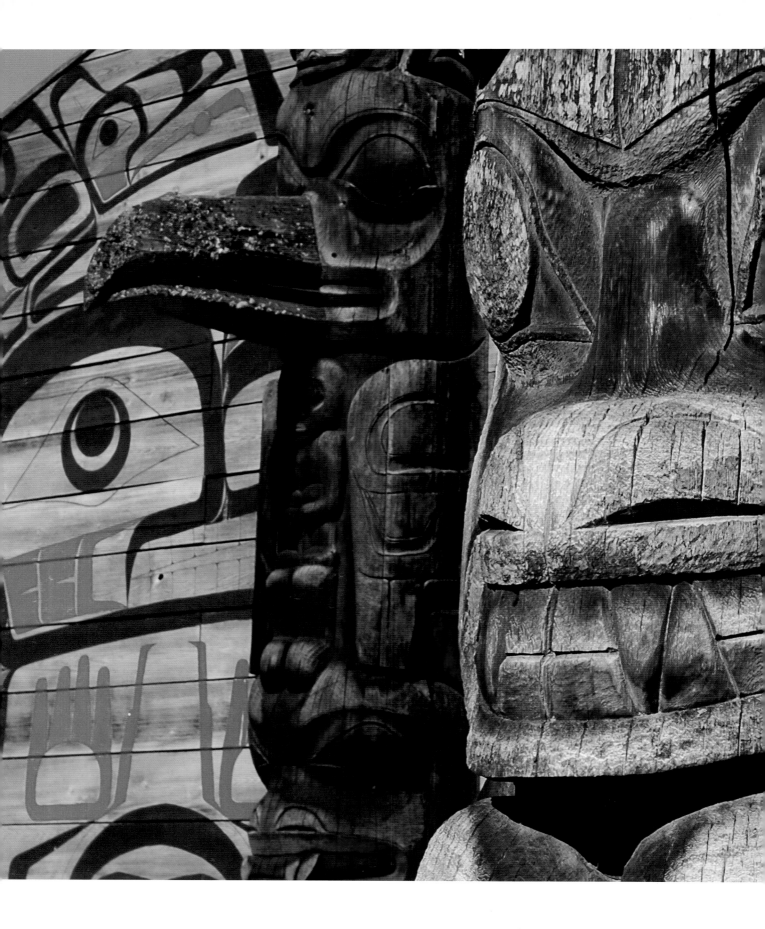

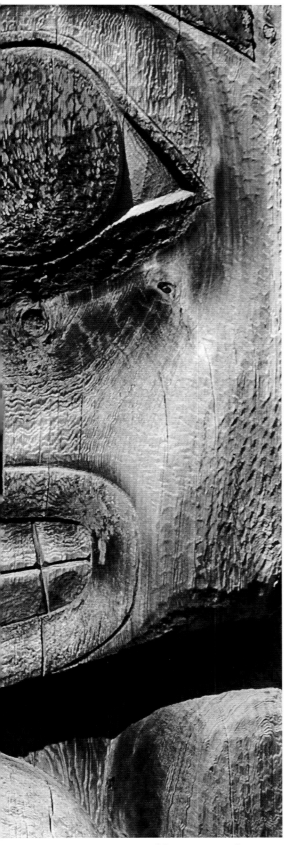

After being suppressed for many years, the artistic traditions of the West Coast underwent a revival in the last century. Modern carvings and paintings are now proudly displayed in many sites, such as Hazelton, British Columbia.

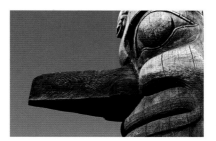

The history of totem poles

When the first European explorers arrived on the Northwest Coast of North America, they encountered a culture unlike any they had ever seen. The regions we now know as Alaska, British Columbia, and northern Washington were home to an extraordinarily rich civilization. Living in a rain forest where food and raw materials were incredibly abundant, the peoples of the West Coast were able to develop a complex society with sophisticated economies and a richly developed artistic tradition. The explorers found much to amaze them, but among the most stunning things they encountered were the pillars that came to be known as *totem poles*.

The name was given by Europeans in an attempt to explain these unusual works of art. It was clear that the people who carved and owned the poles felt some sort of connection to the figures on the poles. To the European mind, the only way to explain that connection was to call the figures *totems* – emblems that somehow represented the tribes. Their explanation was only partly correct, but the name has stuck.

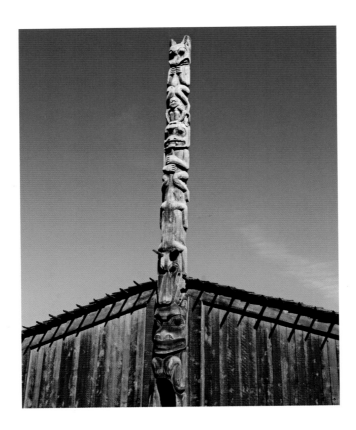

Some of the figures on a totem pole are indeed emblematic of a particular tribe or family. These figures, known as crests, often represent the mythological beings from which a clan traces its origins. The Kwakiutl tribe, for example, has the thunderbird as its crest, because it was believed the thunderbird came to earth and assumed human form and became the ancestor of the tribe. Other clans had other crests. The crest wasn't just seen in the clan's artwork: it was celebrated through stories, songs, and dances, some of which were only to be shared with other members of the clan. All the expressions of this crest – stories, dances, visual images, and even the names that were given to children – were viewed as the property of the clan and could not be used by another clan.

At various significant occasions, a chief would commission a carver to create a pole that featured his clan's crest. When the pole was complete, other families were invited to witness it being erected at a ceremony called a potlatch. There was feasting and dancing, and stories were told. The hosts gave away elaborate gifts, often competing with other chiefs to see who could give away the most wealth. It was common for a chief to give away everything he owned at a potlatch, even on some occasions giving away the very clothes he was wearing.

Clearly potlatches weren't just a celebration of a new piece of art. By attending the installation of a new pole, the other families were giving their assent to its use. Their presence was a way of saying "Yes, we agree that this crest belongs to these people." As such, the poles and the potlatches played an important role in preserving the identity of each community.

West Coast carvers used their skills to carve a variety of different kinds of poles. Memorial poles were erected by the successors of a chief. Occasionally the remains of a chief were placed in a wooden box that was incorporated into the pole; when West Coast people adopted the Christian custom of burying the dead, poles were sometimes used as grave markers.

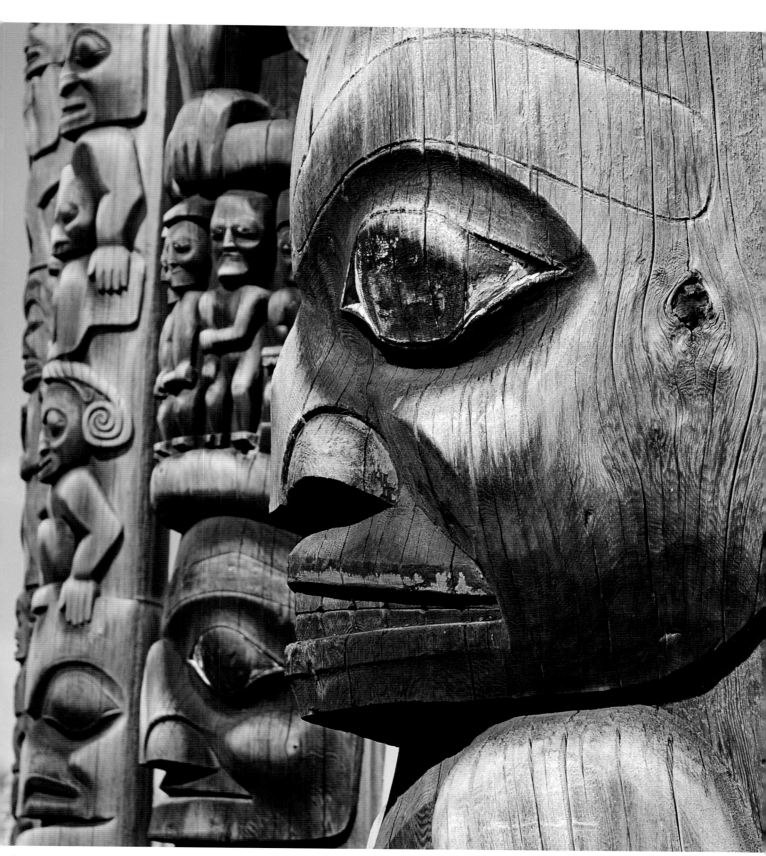

Carving styles varied widely among the West Coast peoples. These poles can be seen at 'Ksan Historical Village and Museum in Hazelton, British Columbia.

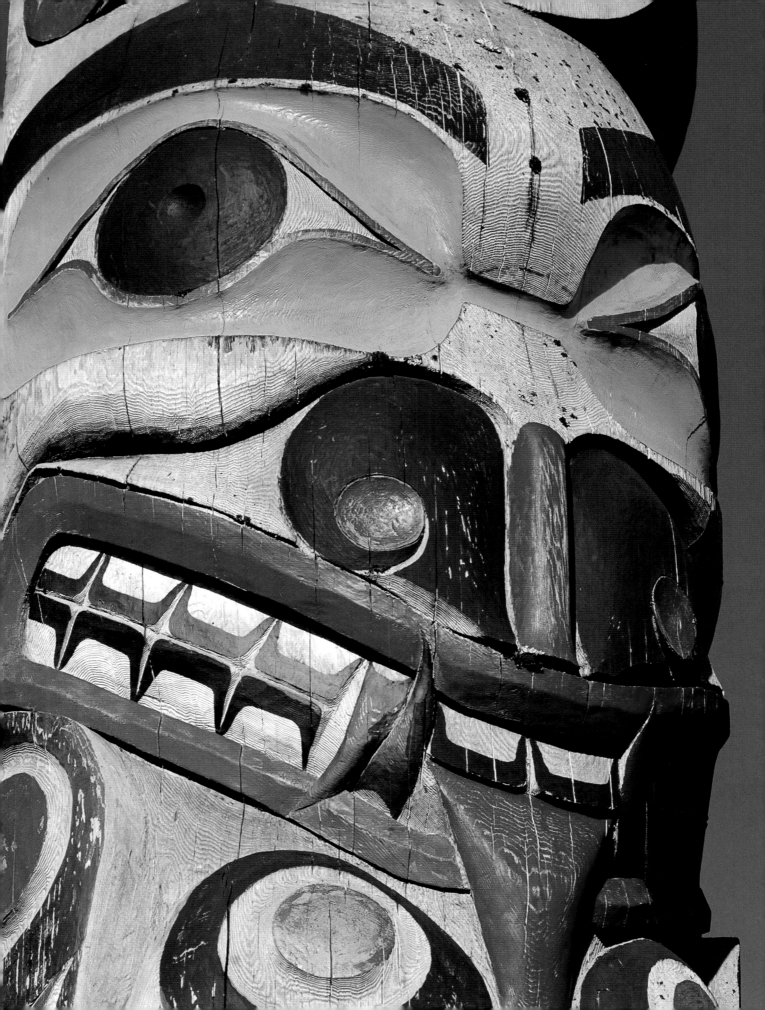

Welcome figures were placed on a beach or a dock to welcome visitors. They usually featured a single figure, often life-sized and usually naked.

House posts served a practical as well as a decorative function, providing structural support to the enormous long houses. Some posts might have a seat carved in the base, often a place of honor. Frontal poles were carved as part of the front of a house, and on particularly large or elaborate dwellings one entered the house by walking through a hole in the pole itself.

The styles of these carvings varied greatly between tribes. Some tribes sculpted deep into the wood, while others preferred to work the surface so that the pole retained its tree shape. The Haida were known for their complex figures, which were so interwoven it was sometimes difficult to tell where one figure ended and another began; Tsimshian and Kwakiutl carvers, on the other hand, had strong horizontal breaks in their poles that separated each figure from the ones above and below it. The proportions of the figures varied, with some making the head as large as the body, others making it half the size of the body, and still others aiming for naturalistic human proportions. There were variations in the use of color, in the presence or absence of pupils in the eyes, and in dozens of other details that allow students of the form to tell one style of pole – and even, in a few cases, one individual carver's work – from another.

At first, the arrival of Europeans brought a golden age of carving. Steel tools, previously unknown to North Americans, made it easier to work the abundant cedar, and artists took their skills to new heights. In the first part of the nineteenth century, it is believed that more and taller poles were carved than ever before. The new visitors were also willing to trade for smaller carved objects, and a great deal of wealth was generated by selling carved rattles, bowls, masks, etc.

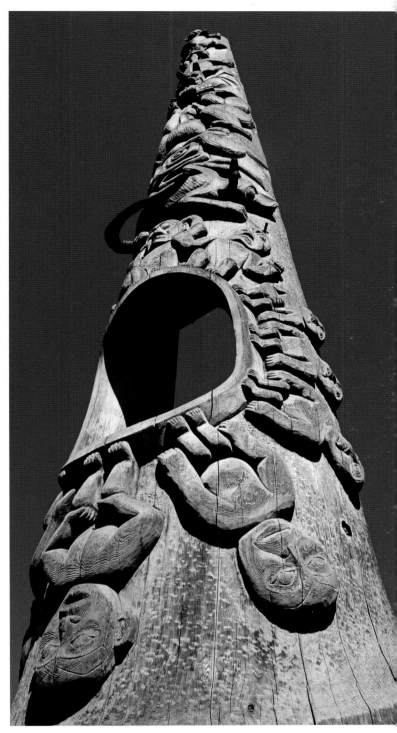

Above – The Hole in the Sky pole was carved 140 years ago. It stands proudly at Kitwancool in the village of Gitanyow, British Columbia.

Left – Many of the oldest poles on the West Coast are now gray and weathered, but it is believed they were once painted like this pole on the Queen Charlotte Islands and have simply lost their colors to the wind and rain.

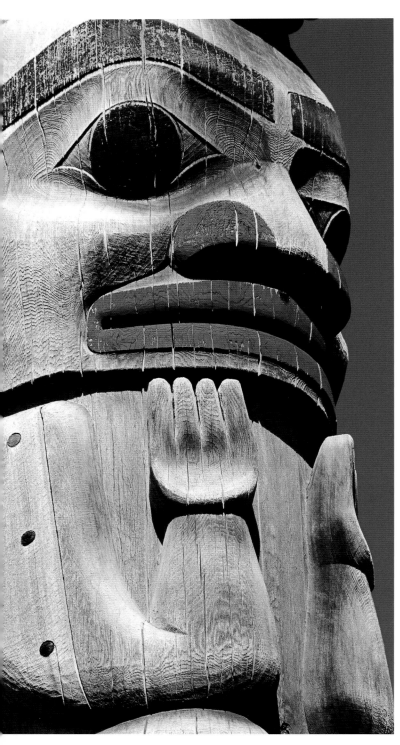

Carving has undergone a renaissance on the West Coast, with many modern carvers reaching or even exceeding the artistry of their ancestors.

But Europeans also brought something much less welcome, and within a few generations deadly diseases – smallpox and measles in particular – had wiped out enormous numbers of people. Among the Haida, for example, it is estimated that 95 percent of the population was eliminated by disease. Old villages and the carvings they contained were abandoned as the few survivors moved away to join other fractured communities.

At the same time, missionaries were urging the West Coast people to abandon their old practices. Some missionaries misunderstood the significance of the poles and thought people built them as idols to worship. Others became concerned about the impact of the potlatches, having witnessed the hardship families would sometimes endure after giving away all of their possessions. And some missionaries simply felt that the First Nations people should give up everything from their old way of life – language, arts, festivals, and religion – in order to embrace both Christianity and a European way of life. In 1880, Canada's Indian Act was amended to make it a crime to participate in a potlatch. The creation of new poles all but disappeared.

Meanwhile, art collectors were becoming increasingly fascinated by West Coast art forms. Museums from the great cities of North America and Europe began to clamor for totem poles and other carvings. Hundreds of artifacts were hauled away to be displayed in New York, Paris, and London. It was another of many great cultural robberies that have been perpetrated all over the world, but in this case it paradoxically helped save the art form.

By the 1940s, the art of carving had all but died out on the West Coast. The Southern Kwakiutl people retained a strong artistic tradition, but in most other communities virtually the only carvings being made were kitschy, crude miniatures designed for tourists. As time went on, even the memory of good carving began to fade. Totem poles don't last in the

Totem poles don't last long in the wild – fifty years is a typical life span before they begin to rot like these Alaskan poles at Ketchikan.

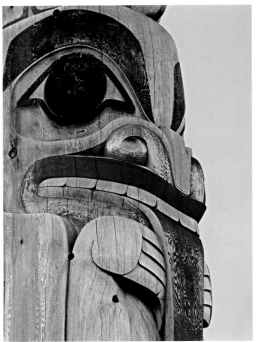 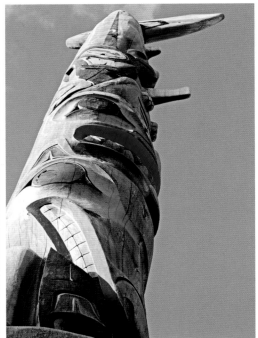

wild – fifty years is a typical life span before they succumb to rot – so when a new generation of Native carvers began to emerge, they often found themselves traveling to museums to study the works of their ancestors. Robert Davidson, one of the great contemporary Haida carvers, went to Vancouver in 1965 to finish high school. "I started to go to museums," he wrote, "and saw for the first time art done by my ancestors, art beyond my wildest dreams, art I did not understand, art whose purpose I did not know."

The law against potlatches was eventually rescinded, and since the 1950s West Coast carving has undergone a tremendous renaissance. Guided by carvers like Davidson, Bill Reid, and others, carving has reached heights of artistry that rivals or even exceeds what was being produced a century and a half ago. Carvers have taken the forms of West Coast art and applied them to new and unique creations, ranging from exquisite silver jewelry to massive bronze sculptures. Once on the verge of extinction, the artistic forms of the West Coast are now alive and thriving as never before.

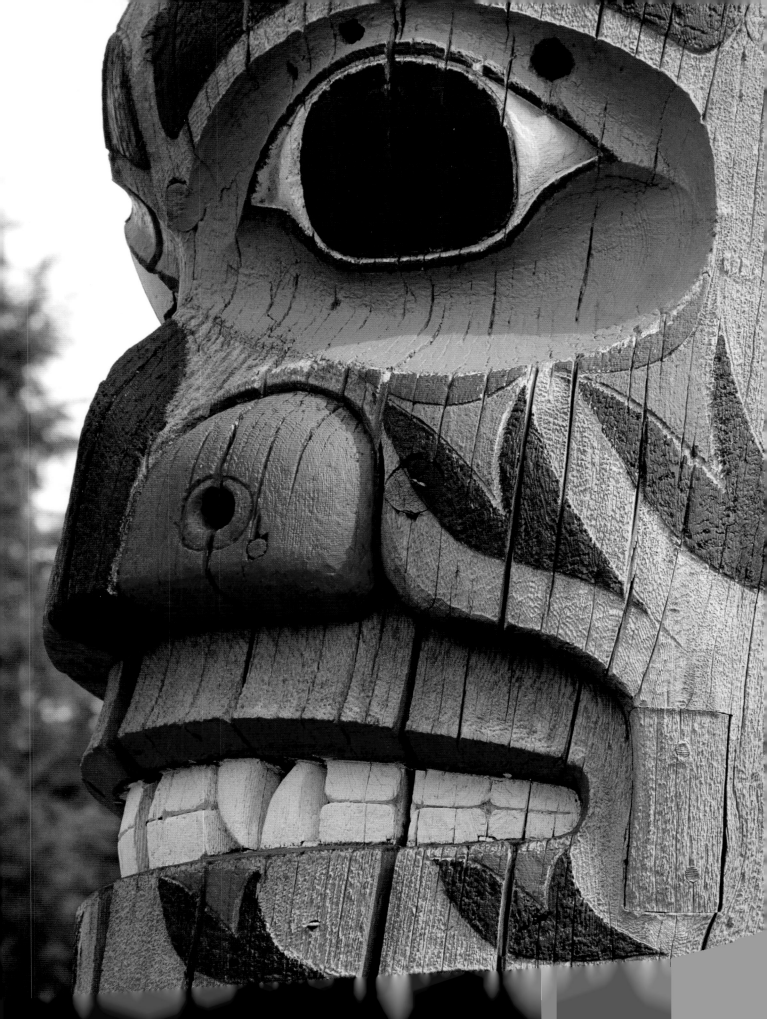

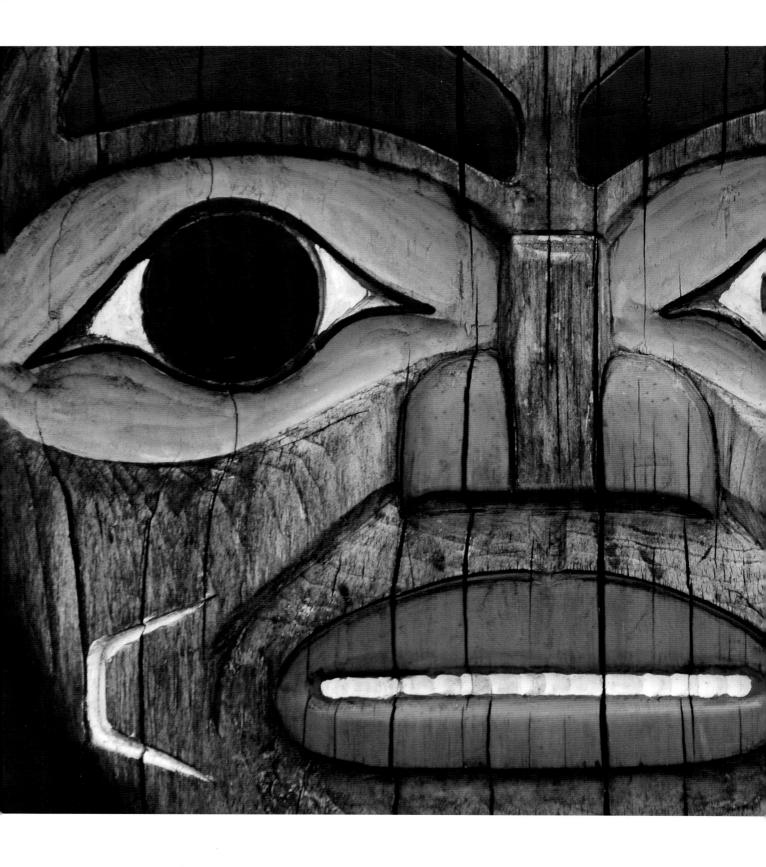

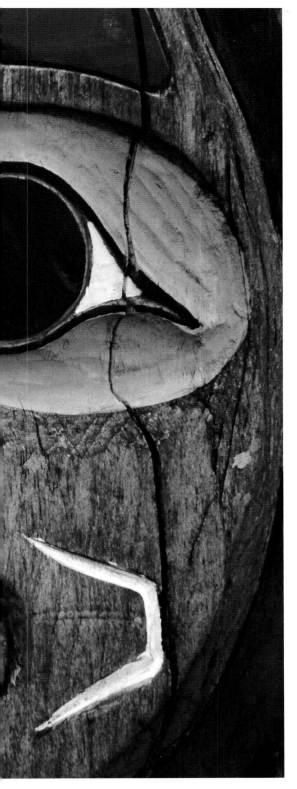

The traditional carvers of the West Coast drew on their surroundings to find symbols they could use to tell their stories.

The designs of West Coast art

Spend some time studying West Coast art, and you quickly see that the creatures in the drawings and carvings have attributes not found in other art forms. An eagle may be depicted with healing hands in its chest, or a salmon's head, or claws. These elements aren't added at random but are used to tell a story or to convey the complexities of a person's character. An eagle depicted with one claw missing, for example, could be a reference to a story that was well-known at the time the carving was made, but which has since been lost.

In all cultures, animals are often used to depict certain character traits. We still talk of people being as brave as a lion, or as strong as an ox. In the appendix at the back of this book, you'll find a list of some of the creatures seen in West Coast art and an explanation of their meaning.

The traditional carvers of the West Coast drew on their surroundings to find symbols they could use to tell their stories. The eagle, the fish, and the bear were a part of their everyday world, so it was only natural that these animals would be used to represent different people or personality traits. Important family or tribal stories worth preserving often involved interaction with wildlife – a great catch of fish, or an unusual encounter with a whale – so animals also appeared on the poles as part of a story, playing themselves, as it were. But most people in the twenty-first-century don't have those sorts of encounters with wildlife. We're unlikely to have any family stories that begin, "One day, when your father was out spearing fish, a whale surfaced

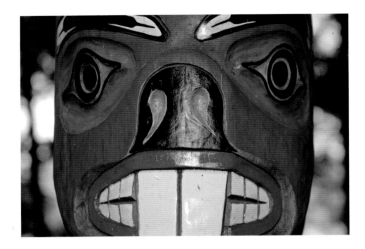

beside his boat...." We also lack the hard-won familiarity with wild creatures that will let us use their characteristics as metaphors for our own personalities. We may still recognize that a coyote is a symbol of cunning and trickery, a beaver is a hard worker, and a cat represents grace and sensuality; but how many of us see a blue jay and think it represents the proper use of power, or regard cranes as a symbol of longevity?

Fortunately, the forms of West Coast art are highly adaptable, and it is remarkably easy to incorporate modern symbols into poles and use them to tell the story of a twenty-first-century individual, family, or company. We have designed countless poles that combine traditional and modern symbols in this way. There's no reason you can't do the same.

Some poles feature literal depictions of an object, in much the same way that a traditional pole might use a whale to represent a significant encounter with a whale. A pole we carved for the non profit group that operates a historical steamship, for example, includes an image of that steamship. A family that plays a lot of music asked to have a keyboard and a guitar included in the design. Golf clubs, cars, skis, and sailboats have all been included in family poles to capture elements of the family's life.

Poles can also include modern symbols that have every bit as much meaning to us as a thunder-bird or a bear had to traditional carvers. We may not even think of them as symbols, but they are elements that are rich in meaning to those who can interpret them. A maple leaf or a shamrock can tell of national affiliation. The masks of comedy and tragedy represent theater. A lawyer may choose to incorporate the scales of justice, while a doctor might opt for the caduceus (with two snakes twined around a staff) or the single-snake staff of Asclepius. There are the insignias used by clubs and organizations, such as the Masonic compass and square; and the world of religious faith is rich in symbols, of which the Star of David and the Cross are just two examples.

Another option is to select symbols that have more personal meaning. Rather than carving her musical instrument or musical symbols, a musician might prefer to incorporate waves as a symbolic representation of her music. A veterinarian could represent his profession by carving a cluster of small animals grouped together on the pole; then again, he might metaphorically view all of his patients as scales on a fish, or feathers on a bird, and carve a single animal that represents all of the animals he treats.

Once you start thinking about the story you want to tell, you'll be amazed at how many symbols and images come springing to mind. In fact, you may find that your biggest challenge is deciding how to fit them all on just one pole.

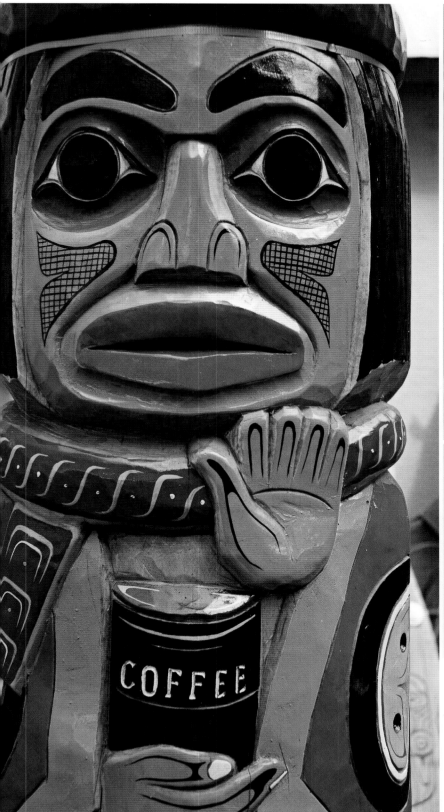

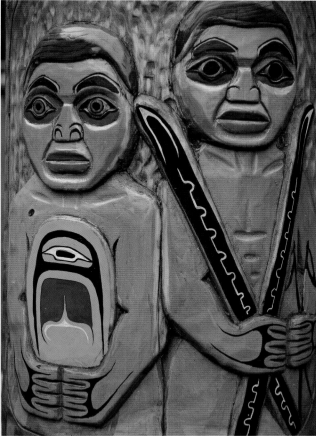

Select symbols that mean something to you. You can have literal depictions, like the coffee can at left or the skis above. Golf clubs, sailboats, and cars have also been included in poles to capture elements of a family's life.

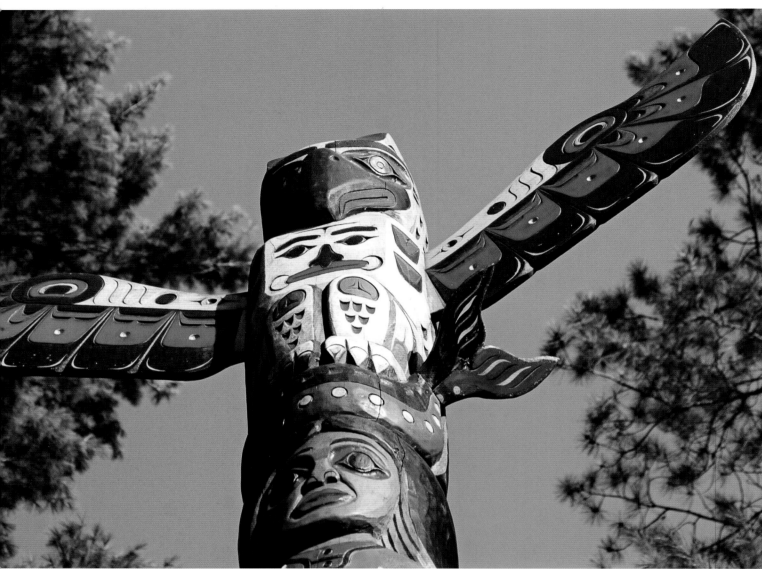

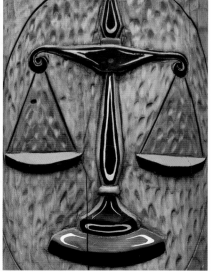

Even without any knowledge of West Coast art, it's clear that the thunderbird on the top of a pole has a positive connotation. It's usually intended to represent power and good luck.

The meaning of a pole's elements can be crystal clear or quite obscure. A set of scales on a pole clearly represents justice and could indicate that the pole was carved for a lawyer. Putting a lobster on a pole, though, is a great way to invite questions.

WHO'S ON FIRST?

The phrase "low man on the totem pole" isn't just an inappropriate misuse of a proud tradition; in most cases it's downright inaccurate. The phrase implies that the figure at the bottom of the pole is the least important. In fact, in almost every West Coast tradition the bottommost figure – the "low man on the totem pole" – is the most important element of the pole's story. On large poles it's certainly the one that will take up a large part of the carver's time, since it's the one that will be seen most closely once the pole is erect. When teams of carvers work on a large pole, it is usually the master carver who works on the bottom 10 feet or so of the pole. The apprentices can work on the figures that will be 30 feet above the ground, where any shortcomings in their carving technique will not be as visible. (The only exception to this rule, as far as we know, is the Tlingit tribe, whose carvers traditionally place the most important figure at the top of the pole.)

So if the lowest figure is not the least important, how do you decide what to put where on your pole? That depends largely on the story you're telling through your totem pole. If it's a family history that stretches over many years, you may want to consider using chronological order so that a path of decades can be traced as one reads the pole from one end to the other.

Another option is to look for thematic connections. Draw a number of circles on a piece of paper; then write in each an element you want to include on the pole. Draw lines between elements that have some sort of connection to each other. You may want something on the pole to represent your love of boating, for example, and you may want to include an image of your father. If your father introduced you to boating, draw a line between those two circles. Don't be limited by links that other people will recognize, either. Look for connections that will have meaning for you, that will make the pole tell the story you want it to.

Once you start to put your design together, remember that West Coast art often tells stories of transformation. It may be literal (there are legions of stories about people turning into animals and back again), it could be figurative (a boy becoming a man), or it could involve elements of both. The same can occur in your pole. People change jobs, move to new locations, acquire new hobbies or interests. Show this by carving creatures with the body of one animal and the head of another, or carve one creature holding another. Remember that the pole, like any good work of art, isn't necessarily meant to reveal its entire story to the casual viewer. It should invite inspection and perhaps prompt the viewer to ask the carver to tell the story.

Scattered along the West Coast, or preserved in museums, there are numerous poles that date back to the nineteenth century. In many cases, even the most skilled student of totem poles can only guess at the pole's meaning. The chief who commissioned the pole and the carver who created it are long gone, taking the story of the pole with them. All that remains is a beautiful piece of art and a delightful enigma. The same fate may await your pole, as future generations admire your workmanship but scratch their heads and wonder what great-great-grandmother had in mind when she carved that. It's not a bad legacy to leave.

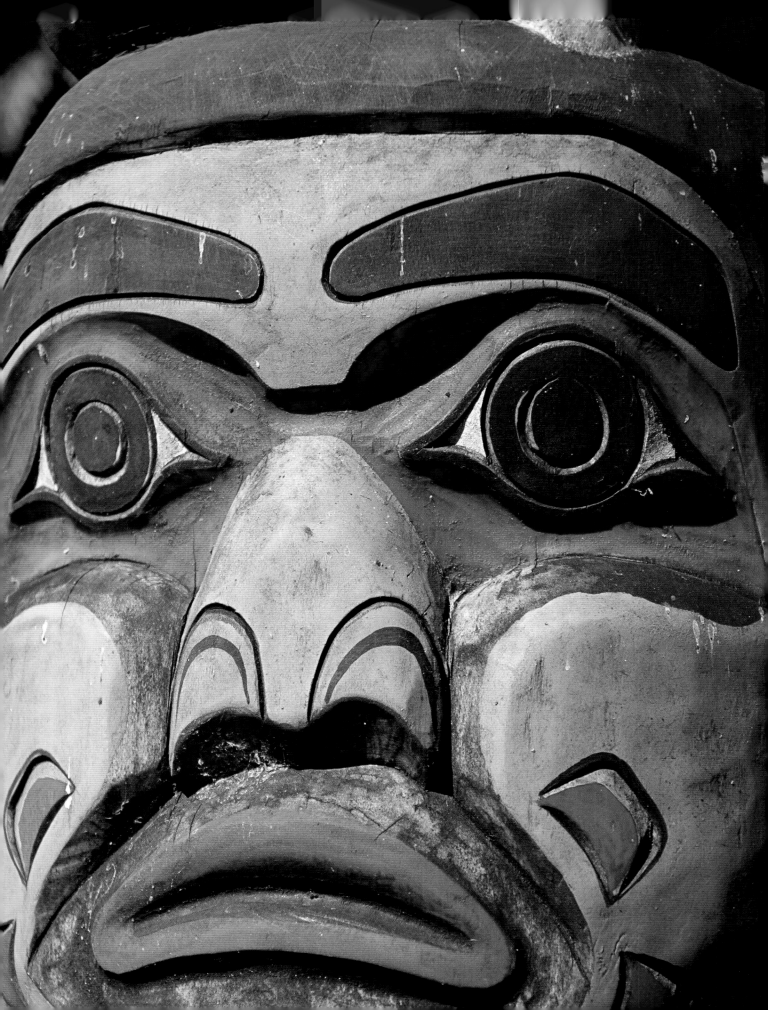

THE FIVE BASIC SHAPES

West Coast carvers have produced a bewildering array of works in a broad range of styles, and it can be intimidating to the beginning carver to figure out where to start. Fortunately, all of the basic carving – and much advanced carving – can be done using five basic shapes. By varying them and combining them in different ways, carvers can create all kinds of figures.

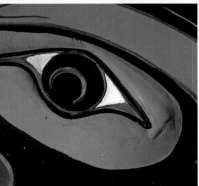

All of the five basic forms are used on these totem poles.

The shapes are: the circle, the U form, the S form, the ovoid, and the split U, along with its negative version, the trigon. Each of these shapes has symbolic meaning from nature, which can be woven into the carving to add depth to its story.

The circle represents completion, as well as the sun or the moon.

The U form is inspired by the scales of a fish, or the layers of a bird's feathers. It is often seen at the base of feathers, or in fins, tails, or other extremities.

The S form conjures up images of a river and represents twists and turns. It is used to fill in an area of the carving, to form ribs, legs, arms, and eyebrows.

The ovoid, which always looks as though it is about to spring out into a circular shape, adds artistic tension to your work. Ovoids are often drawn with a second ovoid within them, which can be positioned to make the upper portion of the ovoid thicker or thinner than the lower portion. The shape seems to have been copied from the skate, a fish that has a clear ovoid pattern on its underside.

The split U is inspired by the shape of a flicker's feathers, each one of which ends in a shape like a split U. The angle of the arms can vary, depending on the needs of the carver. Artists often depict the negative form of the split U in a shape that is known as a trigon. If a fourth arm is added, it is called a quadrigon.

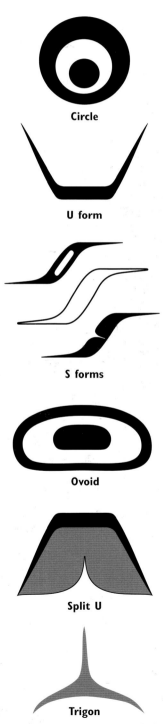

Circle

U form

S forms

Ovoid

Split U

Trigon

COMBINING SHAPES

By combining these shapes, the carver can create a variety of images. This salmon head, for example, is created from an ovoid. Two more ovoids create the eye, while S and U forms are used to fill in the details.

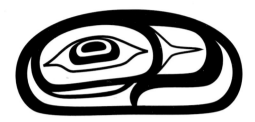

Cheeks

Cheeks

Variation of split U

With a bit of practice, it's not difficult to see how the different shapes are combined to create these shapes.

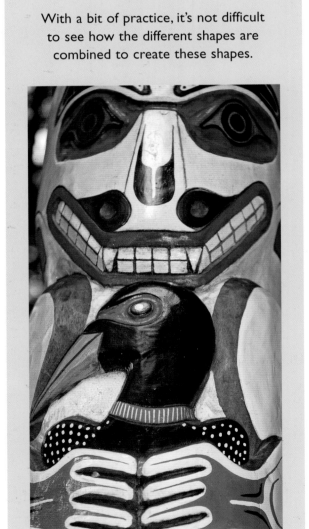

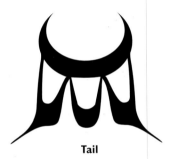

Tail

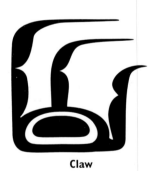

Claw

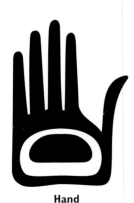

Hand

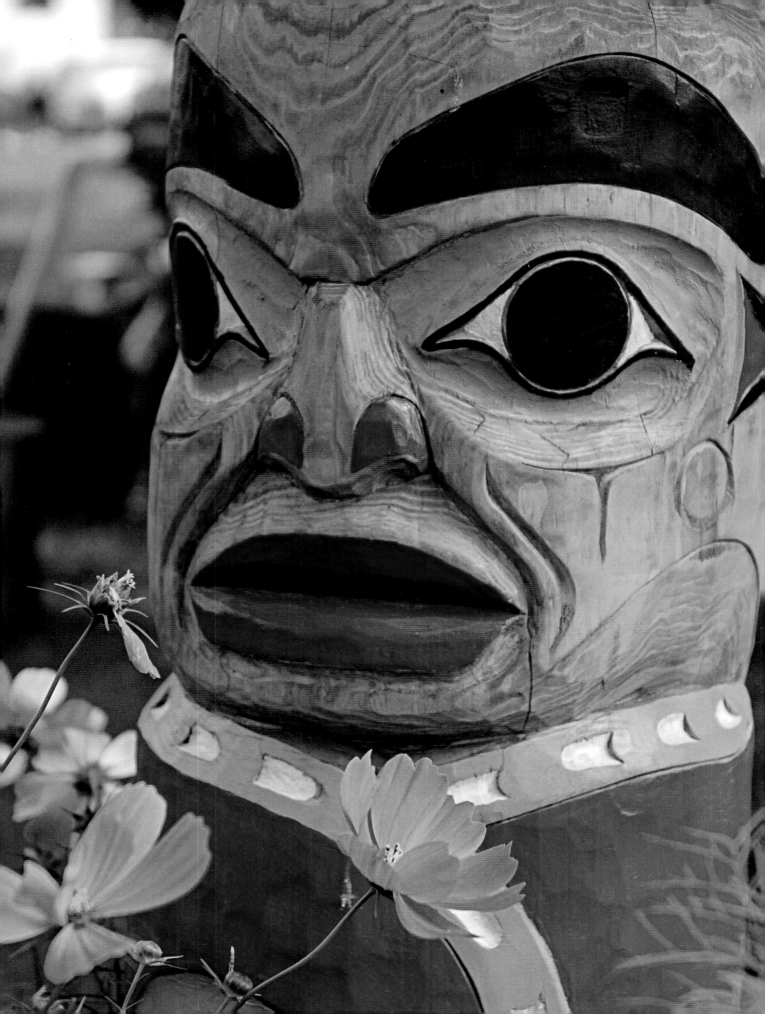

FACES

Eyes are a challenging item for any art form, and carving is no exception. We've all spent a lifetime reading people's emotions by looking at their eyes, so any subtle change in the shape can greatly change the facial expression. As you practice drawing, and later carving, the different elements of your art, you should work particularly hard to perfect the eyes and other facial elements. Keep drawing and carving them on pieces of scrap until you get a feel for them.

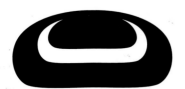

Eye made from ovoid

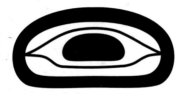

Eye variation

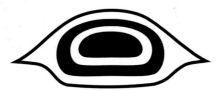

Eye variation

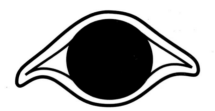

Eye made from circle

Eyes are usually made in one of two ways: for whales and fish, we tend to use ovoids; for most other eyes, we use a circle with a split U on either side. A parallel eyeliner line is drawn around the eye to define its shape when seen from afar. Different pupil shapes can be inserted for expression, but this varies widely depending on tribal custom. Haida carvers, for example, almost never use pupils.

There are a number of other differences in eye styles, which vary widely from tribe to tribe. To simplify the process, we often tell beginners to use a human eye shape, then adjust it to make it appropriate for wildlife – stretch the eye out to make it bird-like, or make the eyelash line a single, gentle curve to make it an animal's eye. The illustrations give some other eye ideas.

Animals usually have eyebrows similar to humans. They can be arched, rounded, or humped.

Noses can be carved with nostrils as ovoids or as circles. They can be enlarged with paint.

Ears are usually either U or split-U forms. The style is typically reflective of animal ears rather than human ears.

The mouth can be closed, showing bared teeth, or open. If the mouth is open, it often contains an abstract art form inside it. Bears are often carved with a protruding tongue.

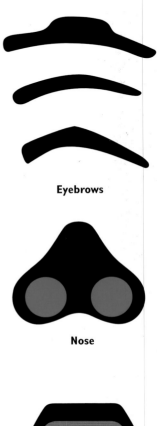

Eyebrows

Nose

Ear

Teeth and tongue

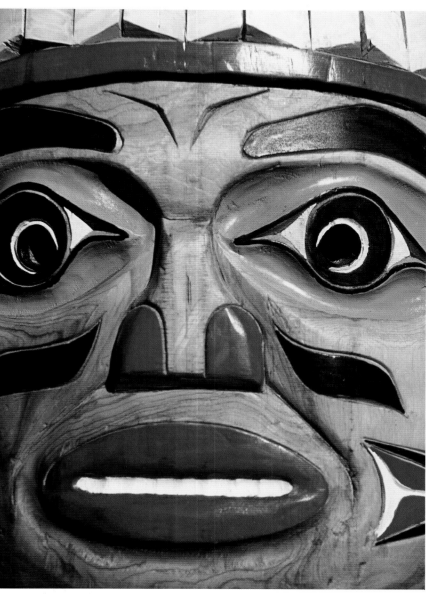
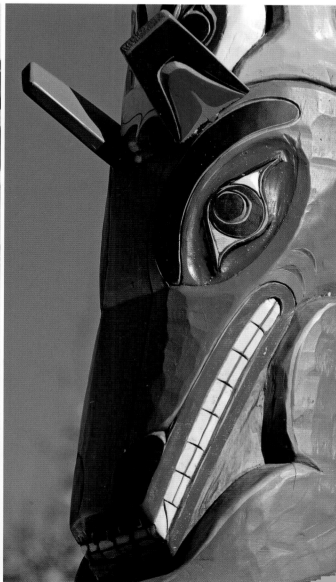

PENCIL FIRST

Once you've got the ideas straight, it's time to start creating your
pattern. Sketch your ideas on a piece of paper. Think about how big the bodies
and heads should be, and try to get the proportions of each figure to the point
where you feel satisfied. Be prepared to make liberal use of an eraser.
Remember that it's a lot easier to change the design now than it will
be when you start carving it.

Be patient. Be prepared to redo and redo the design until you're satisfied.

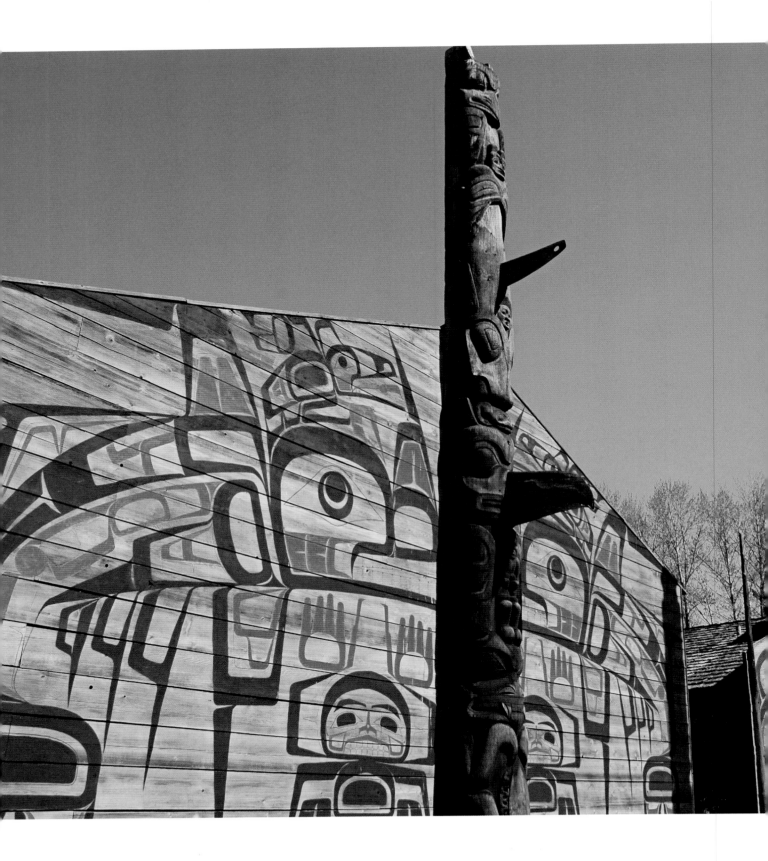

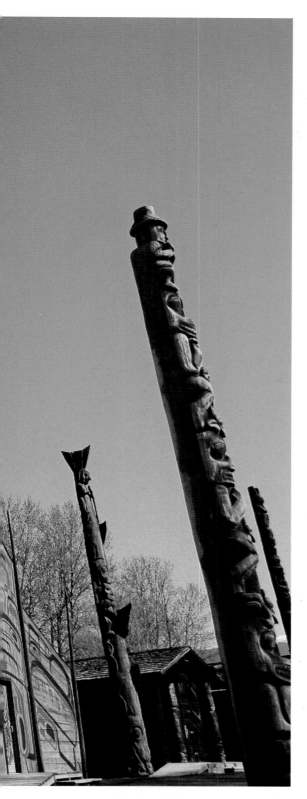

Traditional West Coast artists used the same forms in their artwork, regardless of whether they were working in two dimensions or three.

Two-dimensional art

Now that you're comfortable with the basic principles of West Coast design, it's time to use some of them to create a piece of art. If this is your first exposure to totem poles, chances are you don't yet feel ready to tackle a full-fledged totem pole, or even to try working in three dimensions.

That's just fine, because your first project will involve working in two dimensions, using nothing more complicated than a pencil and some markers. More than just a practice exercise, this chapter will show you how to create some fine pieces of art that you would be prepared to hang on your wall, as well as give you some skills you'll need in order to make your totem pole or other three-dimensional project look its best.

Study any animal depicted in West Coast art, and it's immediately apparent that they're not seen the same way as they are by artists from the European tradition. One of the most striking differences is that West Coast artists often depict both the interior and the exterior of their subjects.

The degree to which this is done is up to the artist, as you can see from the illustrations on these pages. The drawing of the above butterfly focuses entirely on the exterior. Its West Coast feel stems from the use of colors – particularly the thick, black form lines – and the presence of the various traditional forms we discussed in the previous chapter. The turtle on page 35 adopts an

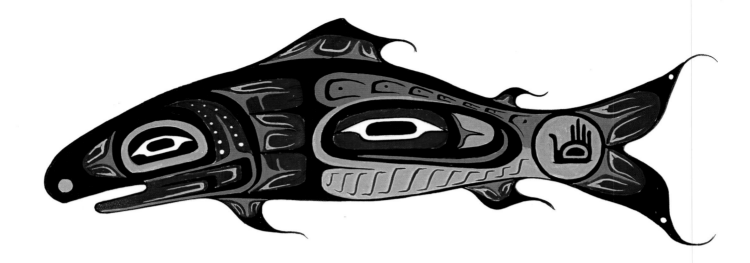

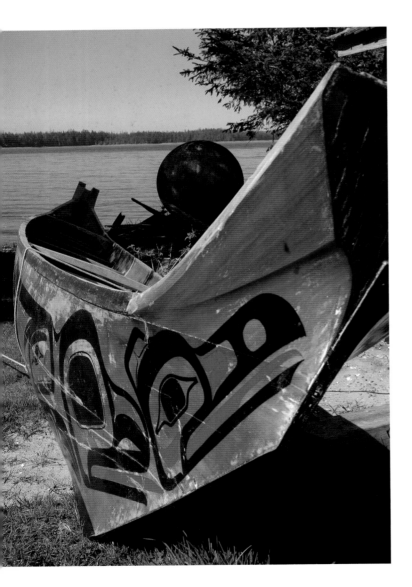

intermediate approach. The shell is largely a depiction of the turtle's exterior – the pattern is similar to the pattern you would see on the back of a turtle in the wild. But look at the legs and feet: the joints in the legs and the skeletal structure of the feet are clearly represented by using ovoids and trigons.

On a drawing such as the above fish, the interior elements predominate. In fact, the outline of the creature and the placement of the eye are the only parts of the design that refer to the fish's exterior features. Interior features can be clearly seen, including the stomach, with the ribs below it and the vertebrae above it. If you look more closely at the stomach, you'll see that it is a large ovoid containing a salmon trout's head, a common interior element in many drawings. In other parts of the picture, you can see the gills and the fine bones that are found in the fins and the tail. There are also elements that seem to have no direct bearing on the fish's anatomy, such as the hand-shaped feature at the junction of the tail, or the series of small circles located behind the eye. These more fanciful elements may have to do with the fish's story – they may represent a magical power, a relationship between the fish and another creature, or something the fish ate, for example – or they may simply be introduced for the oldest artistic reason of all: because they look good.

To get a sense of how artists use the West Coast forms, it's a good idea to begin by copying the works of other artists. This is a well-established

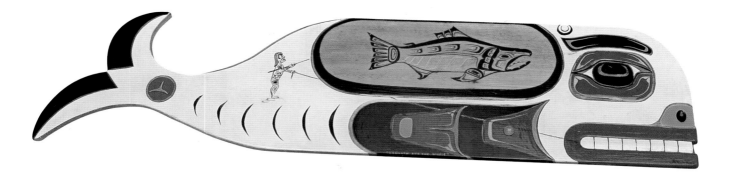

practice in West Coast art, as students learn to create their own works by first copying the traditional pieces. Indeed, in some traditions the apprentice must work on traditional designs for ten years before he is allowed to vary them in the slightest.

Choose one of the illustrations included here, or find another that you like on the Internet. Study it, paying attention to the weight of the various lines and how the thickness of the lines varies. Your eye can tell you that the design includes a split U here or a trigon there, but you need to feel it with your hand in order to be able to make works of your own. Just use a black pencil or marker, and focus on the lines for now. We'll introduce color in a little while.

When you're ready to make a drawing of your own, look for a photo of the animal you wish to depict. Draw the outline of the animal, and think about what it would look like in an X-ray. Decide which of the animal's internal organs – if any – you'd like to depict and what forms could be used to represent them. The thick, black lines in your drawing are called the form lines. They are continuous – there should be no breaks in the exterior form line – but they can be of varying thicknesses to give shape and life to your drawing.

Once you've drawn the form lines around the interior and exterior, it's time to consider the space-filling elements. Large areas of blank space are rarely seen in West Coast art. Instead, forms such as split Us and ovoids are used to fill the space and give vibrancy and movement to the drawing. Deciding how many elements to add is a challenging part of this art form – too few and the drawing looks empty, but put in too many and it will look crowded and overly busy. Experiment with different approaches to see what looks right. The forms can be stretched and pulled in various ways to create a pleasing effect. Where main form lines meet – for example, where a wing joins the body – you may find that the joint appears too heavy. This is where trigons and quadrigons can be used to lighten the region. This negative space will bring more creativity to your art.

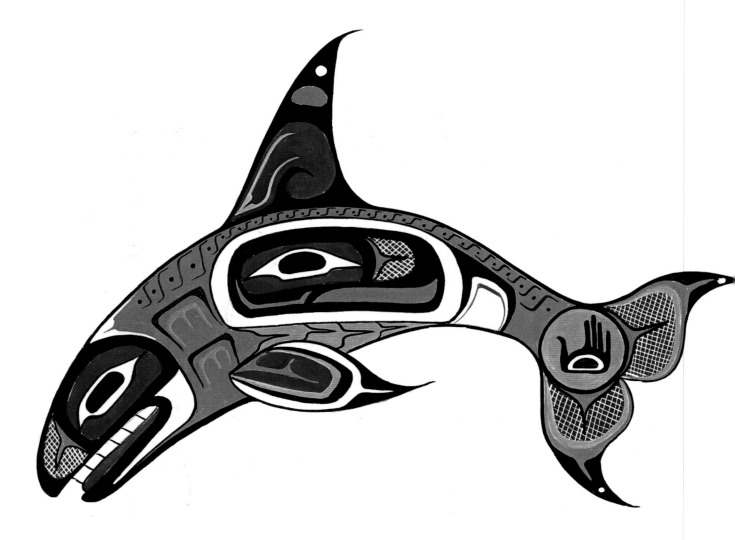

ADDING COLOR

West Coast art can be divided, broadly speaking, into three main groups: northwest, mid-coast, and south coast. They differ a great deal in their form – the south coast has more free movement than the others, for example – and in their use of color. The northwest tribes tend to use just black, red, and green, but we've always been partial to the more colorful works created by mid-coast artists. Our use of color is influenced in particular by the Kwakiutl tribe, who use red, white, yellow, and green or aquamarine, as well as black.

Black is obviously the primary color in this kind of art, as the thick, black form lines dominate most drawings.

Red is usually the secondary color. It is most often placed immediately adjacent to the form line. It is also typically used for certain parts of the anatomy: cheeks, tongues, arms, legs, claws, and feet.

Occasionally, red is used in place of black to create the form line – in the legs and feet, for example, when they are depicted as appendages rather than as part of the creature's main body. In such a case, black would be used as a space-filling secondary color immediately inside the red form line.

White is used in negative spaces – in the eyes, for example, to separate the inner ovoid from the outer form line, or to separate the pupils. The areas inside U-forms, or around interior portions of the body, can be white.

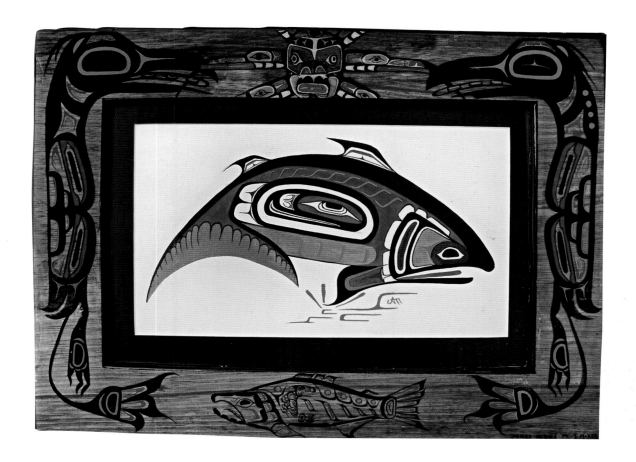

Green or aquamarine are usually used as a tertiary color. They can be used to split a U form, or to make crescents, trigons, or quadrigons. When S forms are used as ribs, they are often painted green. Quite often, when two major form lines meet, green is used to lighten the area.

Yellow is most commonly used when depicting the sun. Like green, it is a tertiary color that can be used to lighten a drawing.

Your first drawings, like your first carvings, will likely be done just for practice. By drawing the different forms, you are teaching your hands to create the lines that you will eventually draw on your totem pole. By trying out different color arrangements, you can get a better feel for ways to achieve balance, as well as understanding what sort of arrangement you find pleasing.

Everyone is going to make mistakes as they learn this art form – just remember that every mistake you make on paper is one less mistake you'll make on wood. As you get more comfortable with the West Coast style, try drawing something a little larger. Get some quality paper and good markers from an art supply store and create a piece to hang on your wall. Not only will you have created art you can be proud of, but you'll find it encouraging to look at when you're starting to learn to carve.

Before taking on a fully three-dimensional mask or pole, it's useful and fun to try carving a flat project. The lines are drawn on wood instead of paper, then carved out with simple V grooves.

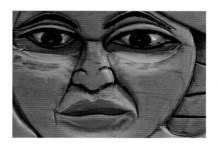

Carving in two dimensions (plus one)

I f you're comfortable drawing, then you're ready to start carving. But before you tackle a fully three-dimensional carving like a totem pole or a mask, here's a project that takes your drawing and coloring skills and applies them to wood. The principles are essentially the same as in the two-dimensional drawings you've been creating this far, but there is an element of carving involved. It's a great intermediate step to get you comfortable moving from drawing to full-fledged three-dimensional carving. And it's a kind of artwork that has a long tradition on the West Coast, where painted wood was found on everything from houses to canoes. We've used this technique to decorate a variety of items, such as the canoe paddles seen on the next page, but it's best to begin by working on a simple piece of wood.

The best wood for this project is pine or cedar. They are inexpensive, soft, and readily available at any lumberyard. Purchase a piece of one-by-twelve, asking for top-grade, clear wood to ensure you don't have to deal with any knots. Some stores will allow you to purchase only as much as you need, while others sell it in precut lengths ranging from 6 feet and up.

Cut the length that you want – the examples seen on pages 33 and 41 were both made from pieces about 4 feet long – and lay it flat on your workbench.

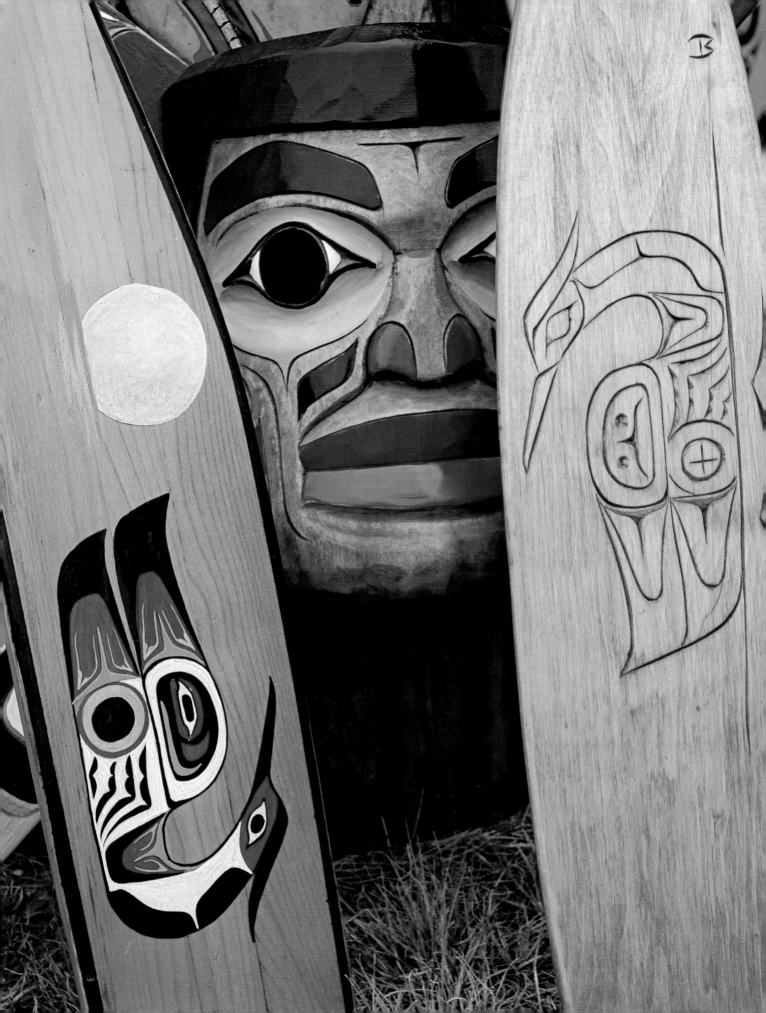

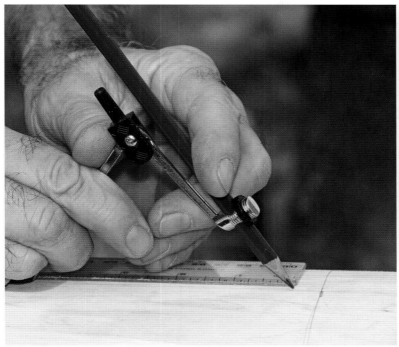

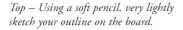

Top – Using a soft pencil, very lightly sketch your outline on the board.

Right – Once your shape is released from the wood, go all around the cut edge with sandpaper, smoothing and slightly rounding it.

Left – The same picture can be carved or painted on, with very different results.

Using a soft pencil, very lightly sketch your outline on the board. If you'd prefer, you can sketch the entire design on paper, then transfer the design to the wood, using the technique described on page 88

Once you've got your outline drawn, use a jigsaw or a band saw to cut it out. If you have a sharp angle to cut – the cleft at the center of a whale's tale, for example – cut into the bottom of the cleft from one direction, then remove the saw and come at it from the opposite direction. That way you're not trying to turn the saw blade around in a narrow space.

Once your shape is released from the wood, go all around the cut edge with sandpaper, smoothing and slightly rounding it. A drum-sander bit in an electric drill will speed this process up considerably, but you can do a perfectly fine job by hand. Start with a 100-grit paper and finish with 300 or so.

Now it's time to pick up your pencil once more. The shape you've cut will be the outside of your form line, so now you can draw the inside of it. Then draw your other form lines for the interior elements.

At this point, it's possible to pick up your paintbrush and start adding color directly, as we did with the paddle in the left of the photo on page 38, but we prefer to give this kind of piece a little added depth by carving some V grooves along the edges of each major line. It's very simple and straightforward, and it's a great skill that you'll use on poles, masks, and other pieces.

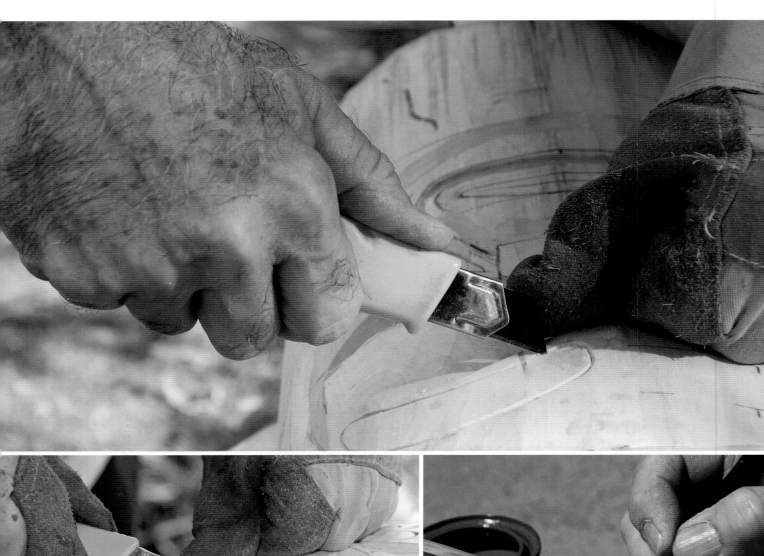

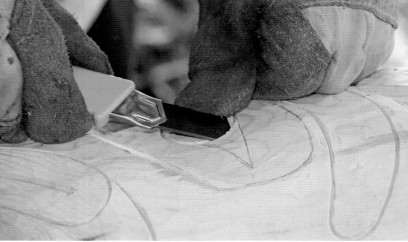

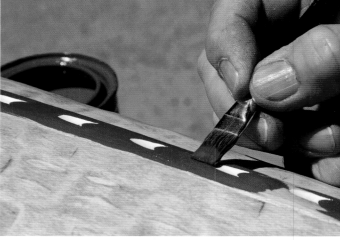

Top – Whether you're working on a flat piece
of wood or a rounded pole, the principle of
V grooves is the same. Use a gloved hand on
the top of the blade to control it and provide
a pivot point.

Keep the width and depth as consistent as you
can – $^1/16$ inch to $^1/8$ inch wide and deep.
At the very end of each line you can make it
taper, so it becomes shallower and narrower.

Try out different paints on scrap wood to see
what you like best.

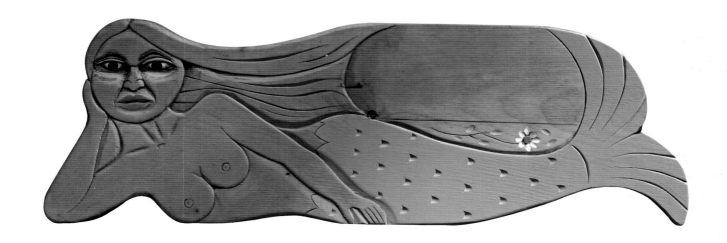

KNIFE WORK

To make the fine V grooves, you'll need a utility knife. The best ones for this purpose have a little wheel that allows you to lock the blade in any position and come with heavy-duty blades. Leather work gloves are essential, as you'll be using one hand on the blade. Hold the knife in your dominant hand – the right hand, for most people – and place the thumb of your opposite hand on the top of the blade, as shown in the photo opposite and in the illustrations on page 58. This thumb will act as an anchor, to help control the blade. Now you can pivot the knife on the tip of the blade to make turns that are as sharp as you wish. It's a good idea to practice this technique on a piece of scrap wood first, until you've got a feel for it. Start by making short, prying strokes and gradually work up to longer sweeps as you feel comfortable with both the knife and the wood.

As with all of the cuts, you want to cut angles, first on one side of the line and then on the other. Try to keep the width and depth as consistent as you can – about $1/16$ inch to $1/8$ inch wide and deep.

Once you're comfortable carving V grooves, you can start carving them on your project. By and large, you should carve a V groove at each point where two colors will meet. But this rule is malleable and can be broken. You may prefer to paint some elements on without carving a V groove; you may even prefer to only carve a V groove around the major form lines. You're in the driver's seat here, so you can steer.

ADDING COLOR

When you're satisfied with the V-grooves you've carved, it's time to add some color. Chapter 10 contains a full discussion of painting and sealing totems, and the same principles apply to painting this project. As you'll read there, we like the bright, vibrant colors that come from using Tremclad paint, but there are other options. When we first started painting totems, we often used milk paints, which impart a light, almost translucent color to the work. Once again, the best approach is to try out some different paints on scrap wood and see what you like best.

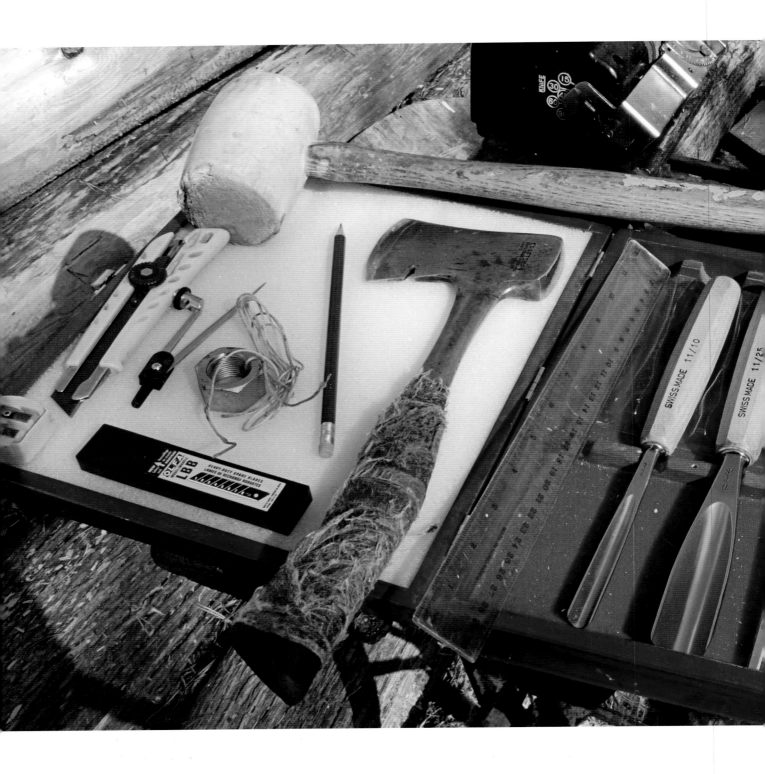

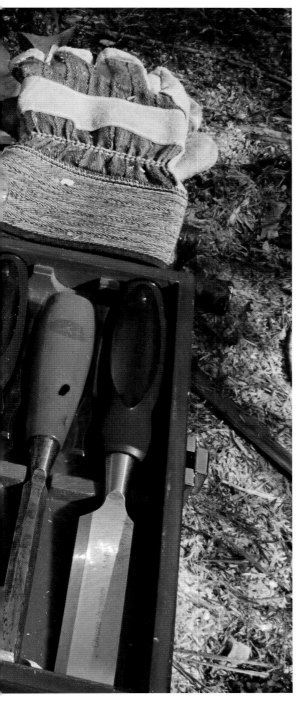

A small assortment of tools is all you need to produce stunning results. Buy good quality tools, and keep them sharp.

Tools and wood

The earliest carvers used a variety of implements, including hatchets and knives made of sharp flint, and hard shells that could slice through the soft cedar wood. But once steel tools appeared on the Pacific Coast, flint axes and shells were quickly abandoned in favor of the new, sharp-cutting implements, such as crooked knives and hand adzes. Steel tools are still the carver's best friend, and you can buy a crooked knife or hand adze if you wish. They're satisfying tools to use and will give your pole an added touch of authenticity when you recall the process of carving it.

However, there is another way of carving poles, using tools that are more widely available and that the amateur woodworker or home handyman is more likely to have used: chisels and gouges, and the lowly utility knife.

A professional carver will have a collection of dozens of chisels and gouges in various sizes. To carve your first pole, though, you can get away with a much smaller collection of tools. Many of the tools are inexpensive, and even the chisels and gouges are not outrageous. Because you're not buying many tools, you should resist the temptation to skimp on quality. A good chisel or gouge will feel right in your hand, meaning you can spend more time carving before you get tired. It will be easier to sharpen and will stay sharp longer. That kit of three chisels for $9.99 at the hardware store may look like a bargain,

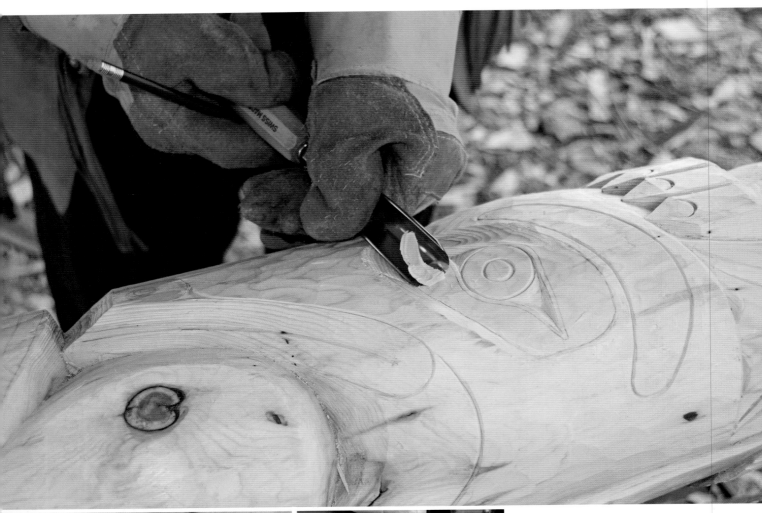

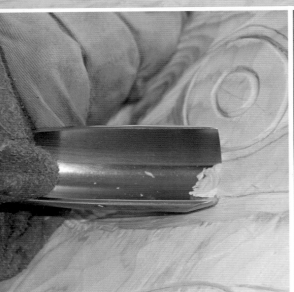

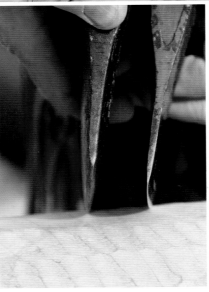

A parabolic gouge can be heeled over to make wide and shallow cuts (above) or held straight up and down to make narrower and deeper cuts (left).

The main difference between a carving hatchet and a woodsman's hatchet is that the carving hatchet has a narrower entrance which allows it to penetrate the wood more easily.

but you'll regret it long before you finish your first pole. Buy the best you can afford, look after them, and your grandchildren will still be using them long after you're gone. Your chisels may even outlast the poles you carve with them.

HERE'S WHAT YOU'LL NEED TO START:

CHISELS

For such a basic tool, it's astonishing how many designs of chisel there are. Long-shafted mortise chisels, specialty crank-neck chisels, short and stubby chisels designed to fit into a tool box. For pole carving, you want ordinary bench chisels. The length of the blade is not important, but you need three widths to start: $1\,1/4$ inch, $3/4$ inch, and $1/4$ inch.

GOUGES

As the name implies, these are used for gouging out the wood. They're sold in a variety of shapes and sizes and are classified according to their width and *sweep*. If you look at a #1 gouge from the end, you'll see that the cutting edge is almost flat, like a chisel; #2 has slightly more curve, or sweep, and so on. You'll be using #11-sweep gouges. Some toolmakers design their #11 gouges with a simple half-circle sweep, but the ones we prefer have the blade shaped in an almost perfect parabolic arc. The great advantage of this kind of gouge is that it offers you several angles in one. Hold the gouge with the sharp end pointing toward you so that you're looking straight at the "U shape" of the blade. See how the curvature at the sides of the U is different than the curvature at the bottom? In practice, that allows you to carve several angles, depending on how you hold the gouge. Hold it so the bottom of the U is cutting into the wood, as in the bottom-left photo, opposite, and you'll carve a fairly deep, straight-sided channel; heel it over so the side of the U is doing the cutting, as in the upper photo, and you can carve a much shallower

channel. Two sizes will do to start: $1\,3/8$ inch and $5/8$ inch. There are a number of good brands on the market, but we prefer Swiss-made Pfeil gouges. They're good tools, the sweep is right, and they are nearly razor sharp when you buy them — just a light buffing, and away you go.

UTILITY KNIFE

Here's a tool that doesn't cost much money at all. Look for the version with a wheel lock that allows you to extend the blade as much as you want, then lock it in place. Buy one that feels good in your hand, and get the heavy-duty blades.

RUBBER HAMMER

Yes, a wooden mallet looks much more authentic, and that *thwack* of wood striking a wooden chisel handle sounds right to the ear. But after a few hours of work you'll start to feel every blow rattling up your wrist. Buy a rubber hammer. Your tendons will thank you.

CARVING HATCHET

This is another tool for which it pays to buy quality. We prefer a solid-steel hatchet, but there are also superb carving hatchets made with wooden handles. A key feature to look for in a carving hatchet is its *entrance* the thickness of the tool as it angles back from the blade. If the entrance is too thick, then the blade will not penetrate into the wood, no matter how sharp it is. A regular hatchet can be made into a carving hatchet by sharpening to narrow the entrance at least $5/8$ inch back from the blade.

WORKBENCHES

Those foldable benches sold at every hardware store are ideal for totem pole carving. Easy to set up, strong enough to support a log, and not very expensive. You'll need two.

CHALK LINE, TAPE MEASURE, PAPER AND PENCIL, CLIP BOARD.

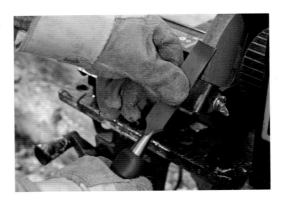

SHARPENING

There is nothing more gratifying to a wood-carver than to cut into a fresh piece of clean cedar or basswood with a freshly sharpened wood-carving tool. Not only does a sharp tool feel better to use, but it allows you more control over your work. You won't find yourself struggling to force the chisel or gouge through the wood, only to have it push farther than you intended, or jump free and mark your work in an unexpected place.

There are a number of ways to achieve that satisfying sharp edge, but the most effective in our experience is to use two wheels on a bench grinder, as well as a water stone. If the tool has any nicks or scratches, you should begin with a medium wet wheel or an aluminum oxide wheel on a bench grinder. With the wheel turning toward you, press the tool against it so that somewhere between $1/2$ inch and $5/8$ inch of the tool is touching the wheel. Move the tool from side to side, pressing lightly against the wheel. Dip the tool in water after each side-to-side stroke to keep it cool. Be careful not to grind right to the edge, as the wheel can overheat the tip of the tool, burning the steel and compromising its temper.

Once you've removed any nicks or scratches from the cutting surface, move over to a water stone or an oil stone. Use a circular motion to rub the tool against the stone, starting with the rough side of the stone then moving to the fine side. Try to hold the tool at a constant angle. Honing guides – devices that clamp onto a blade and hold it in place – are an inexpensive and effective way to do this. They're available from many hardware stores and from nearly all woodworking supply stores.

Finally, it's back to the bench grinder, equipped with a medium felt wheel which you've rubbed with buffing compound. This time you want to hold the tool so that the wheel is turning away from it. Never turn the felt wheel toward the tool – the felt can catch the end of the tool, sending it flying back toward you. Again, move the tool back and forth, holding it lightly against the wheel.

Once you're done, position your sharpened tools carefully on the bench so the tips don't touch each other.

This is just one of many ways to sharpen tools. Indeed, entire books have been written on the subject. Other woodworkers prefer to use a series of grinder wheels, or a series of water stones or oil stones, or even varying grits of sandpaper glued to a sheet of glass and oiled. One of our students bought a professional sharpening machine to ensure his tools would always be at their sharpest.

Regardless of how you do it, your tools must be sharp if you are to carve well. How sharp? Well, in one of our classes a surgeon picked up a chisel and lightly touched the end to see if it was sharp. He cut himself.

That's how sharp.

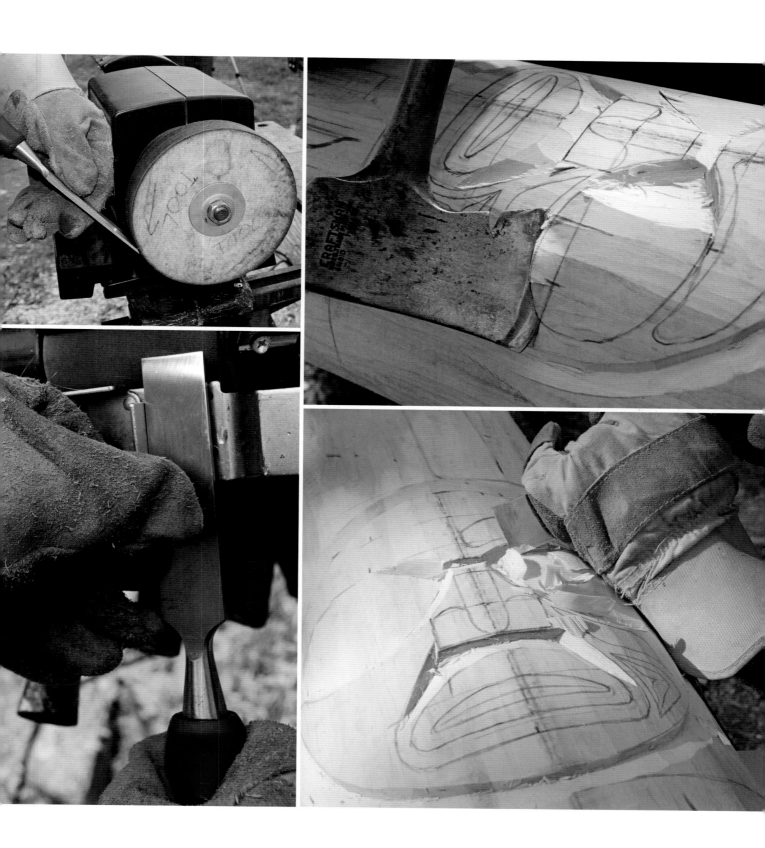

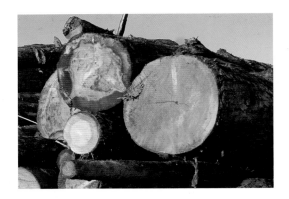

SELECTING YOUR WOOD

Traditionally, cedar was the only wood used for totem poles. It grows abundantly in the rain forests of the Pacific Coast, and the entire tree played a significant role in the lives of the region's residents, providing everything from building materials to medicine to clothing.

For modern carvers, cedar is still an excellent choice for a pole that will be used outdoors, as it lasts longer than just about any other wood. It is also a richly fragrant wood, and its scent will make your workshop smell wonderful. It does, however, have a tendency to split along its length, a condition known as *checking*. Over time it will also develop a series of small cracks over its entire surface.

Whether they're carving totem poles, duck decoys, or miniature figurines, many modern carvers now choose to work with basswood. It's classified as a hardwood but is in reality quite soft and easy to carve. Because it has very little sap, your tools will stay sharp longer. The wood is clean and white when freshly cut, and unpainted basswood mellows to a beautiful yellowish tinge as it ages. In fact, basswood looks quite old in a fairly short time. Like cedar, it's quite light when it's dry, but basswood is very heavy when it's still green and wet. Basswood is ideal for interior projects, but it needs to be thoroughly sealed if it is to go outside. Even then, it's not likely to last as long or as well as cedar.

Whatever wood you use, any pole will need to have a *stress cut* in the back – a cut that runs the length of the pole and acts as a kind of deliberate split, ensuring that the front doesn't split as the pole dries. The easiest way to cut one is to decide which side of the log will be the front, then run a circular saw along the length of the log on the back side, with the blade set to reach about a third of the way into the log. As the log dries, that cut will open up further.

For your first pole, look for a log that's anywhere from 4 to 9 feet long, and around 9 inches in diameter. Look for a log that's straight and free of knots. Make sure it's freshly cut and green – dry wood is ideal for furniture making or building construction because it doesn't shrink or twist, but it's much more difficult to work than green wood. For totem poles, the fresher the better.

If you are planning to cut down your own tree – and please, only do this on land you own or have been given permission to cut on – you'll be looking at standing trees. Otherwise, you need to start calling around, because lumberyards don't carry the kind of wood we need.

The best place to start is with a firewood dealer. Many of them "farm" woodlots, so they are constantly cutting and hauling logs. Basswood is not a valuable species for their purposes – it burns too fast and hot when it's dry – but they often need to remove undesirable trees in order to keep the forest healthy. Ask them to keep an eye open for a straight basswood log, 9 or 10 inches in diameter, and set it aside for you. Forty or fifty dollars is a reasonable price for a log like that, depending on where you are.

Cedar can be a bit more challenging. British Columbia cedar seems to grow straight up before it puts out branches, but in other parts of Canada most cedar trees seem to have too many lower branches – and therefore knots – for our purposes. We've looked around in various areas of Ontario, and the only

place we've been able to consistently find good quality cedar is in the Orillia area. We're not sure why, but the climate and soil seem to favor this kind of cedar growth here, and it's not unusual for us to find cedars that have no branches at all for the first 15 to 30 feet.

Again, firewood dealers are probably your best source of logs. Make it clear that you don't want any knots – those logs are only good for fence posts.

Sometimes you will cut down a cedar tree and find that it has heart rot through the middle. These are not good totem pole trees, as you need the heartwood to attach the mounting rod. However, they make superb masks: the heart rot saves you all of the grunt work involved in carving out the back part of the mask.

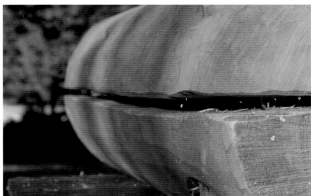

All poles need a stress cut in the back to ensure the pole doesn't split as the wood dries. The cut in the above photo is deeper than a typical stress cut. Usually the cut only goes a third of the way through the pole, as seen in the example on page 86.

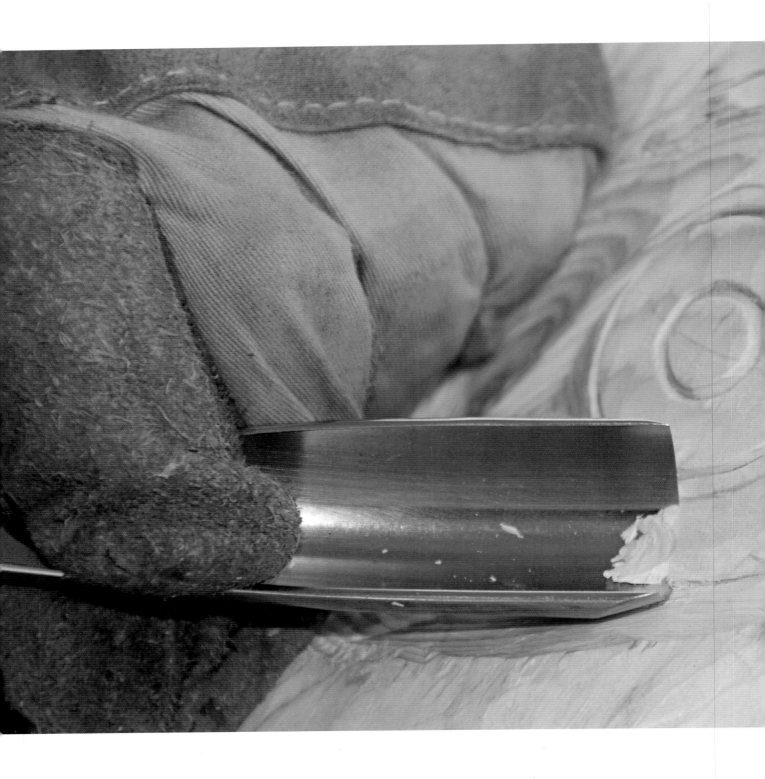

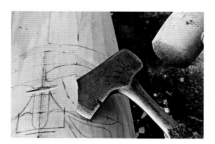

Beginning to carve

Y ou've got the log, the design, and the tools. Now all you need to do is start carving. Before you do, you need to absorb a few safety tips. Don't just learn them: internalize them so that you won't even dream of using your tools in an unsafe fashion. Remember, you've just learned how to make your chisels and gouges sharper than a surgeon's scalpel – you don't want to use them to cut the same material a surgeon does. Follow these safety tips, and keep your hands and other body parts safe.

When gouging around the eye, or making any other delicate cuts, remember not to make the sides of your cuts too steep.

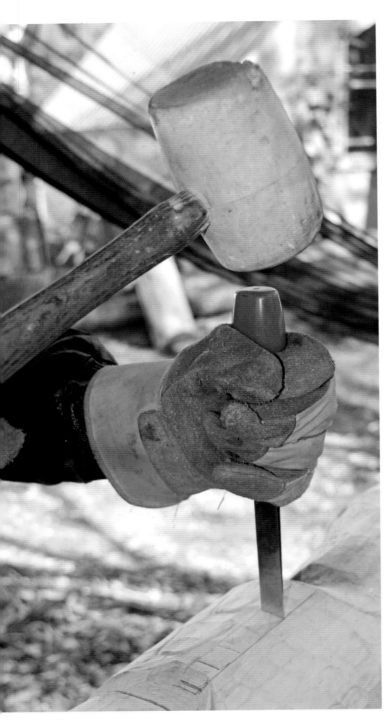

To adjust the depth of your cut, move your hand up or down the mallet handle.

■ Always use tools with two hands. If both hands are on the handle, then they can't get in front of the blade.

■ Always push the tool away from your body. There may be times when this isn't possible, so you'll need to use your judgement. But as far as possible, push away rather than pulling toward you.

■ Wear gloves, not for the reason you think – leather gloves won't stop your sharp chisels from cutting you – but because they will keep you from getting blisters on your hands. Blisters make it more difficult for you to keep a good grip on the tools.

■ Wear a good mask while sanding. Cedar contains plicatic acid, and ongoing exposure to it can cause or exacerbate asthma and other respiratory tract infections. Chronic exposure has also been linked to cancer. Concentrations are highest in western red cedar, but eastern and other cedars also contain plicatic acid. Pine contains abietic acid, which can cause allergic reactions as well as forming carcinogenic compounds when it oxidizes. Basswood dust is not toxic, but inhaling fine wood particles of any species can cause all kinds of respiratory problems. Bottom line: sand outdoors if you can, or vent your woodshop well, and wear a mask.

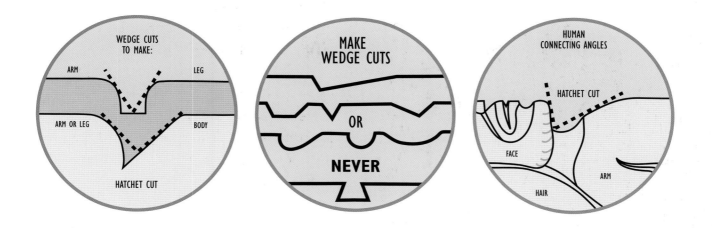

FIRST CUTS

The first tools you reach for will be the hatchet and mallet, or rubber hammer – the biggest tools to make the deepest cuts. Hatchets can be a bit intimidating to use if you think of them as miniature axes that need to be swung with precision. It's much more helpful to think of them as oversized chisels with big handles on the side. You won't be swinging the hatchet; you'll be tapping it with the mallet, a technique that gives you much more control over the work. In fact, with practice you can make remarkably subtle cuts with a hatchet, using the very edge of the hatchet blade and the lightest taps of the mallet.

To adjust the depth of your cut, move your hand up or down the mallet handle. Hold it near the head, and you'll be able to hit the hatchet very lightly; hold it further down the handle, and you'll be able to deliver harder blows. But always remember that you're *carving* the tree, not trying to chop it down!

Look for the spots in your design where you need to remove the most wood, and begin there. In most cases you should hold the hatchet at an angle to the wood rather than cutting straight into it. The object is to cut wedges, a series of V-shaped lines that you will then come back and shape and smooth out. Cut one side of the wedge. Then hold the hatchet on the opposite angle, and remove the wedge.

Some wedge cuts will be quite shallow: the lines around the ears, for example, are not usually very deep. Others will be steep on one side and shallow on the other: the chin line of a face (or the beak line of a bird) drops back sharply to the neck, but the chest below it may taper gradually out again. The same asymmetrical wedge cut can be seen at the bottom of a foot or an arm.

Take your time and be patient. If you're not sure whether you should take a wedge cut deeper, it's usually best not to. If you find that you haven't removed enough material the first time around, you can always come back and take out more.

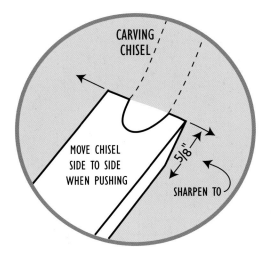
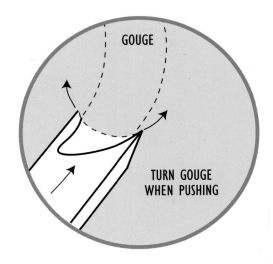

CHISEL AND GOUGE

Now it's time to go back over your work and use the chisel and gouge to shape and smooth it out. This is work that was traditionally done with a crooked knife. Some traditional carvers still use a crooked knife to great effect, but most people find it much easier to get used to chisels and gouges.

Hold the chisel so that the flat part of the blade is lying flat on the wood and you can rub it back and forth without cutting into the wood at all. Then slowly raise the handle so that the blade begins to catch the wood, taking off the high points. This technique is known as *skimming*, and that's exactly what you want to do – skim along the surface of the wood, smoothing out the hatchet marks by removing small chips of wood. Don't worry about leaving tool marks behind – they can be removed later if you wish.

To cut deeper into the wood, simply raise the handle a little higher to adjust the angle of the blade. You will need to do this when you want to *release* a wedge cut, that is, to cut from the surface of the wood down to the bottom of a wedge cut.

If you need to get a bit more force, use the rubber mallet. As you did with the hatchet, hold the mallet closer to the head for lighter cuts and farther down the handle for heavier cuts.

To carve eye sockets, such as the one at the centre of Figure A opposite, you'll want to use two gouges: a 5/8 inch or larger gouge for the broad cuts above and below the eye, and a smaller 3/8 inch gouge for the sharp cuts at the end of the eye. The blue lines indicate where each kind of gouge should be used.

Gouges can also be used to carve feathers or scales, such as those seen on the left side of Figure A. Make the first cut by holding the gouge nearly perpendicular to the wood and pressing it in; then make the second cut with the gouge at a shallower angle, scooping it toward your first cut.

The gouge you use and the distance between cut one and cut two will determine the shape of the feather or scale.

The right side of Figure A shows other ways a gouge can be used: to sculpt the area around a mouth, to carve an eyebrow, or to make two different kinds of circles. Large circles such as the pupil of an eye are usually carved with a knife, but a small circle for a fish eye or frog eye can be carved by holding the gouge perpendicular to the wood and moving it in a circular motion. The gouge can also be used to scoop out circular areas, a design element which is often seen on wings or rays. You can see an example on page 99.

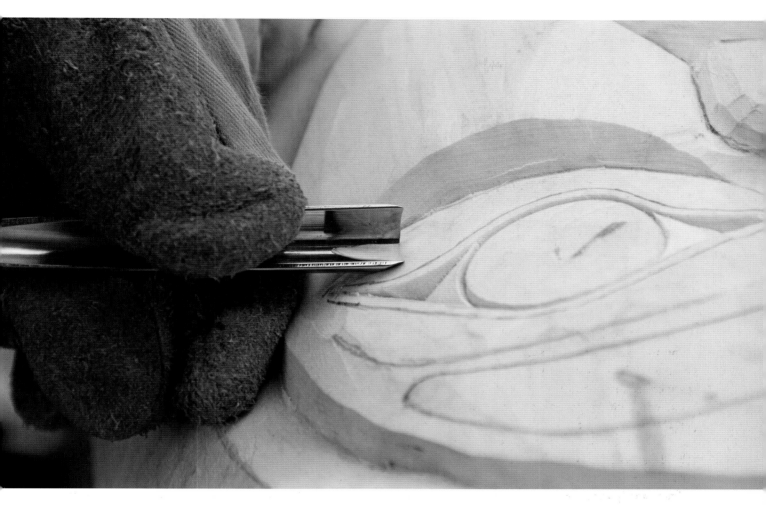

FIGURE A

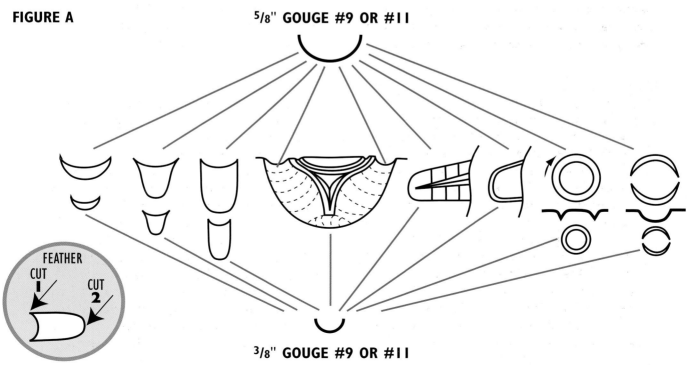

⅝" GOUGE #9 OR #11

FEATHER
CUT 1
CUT 2

⅜" GOUGE #9 OR #11

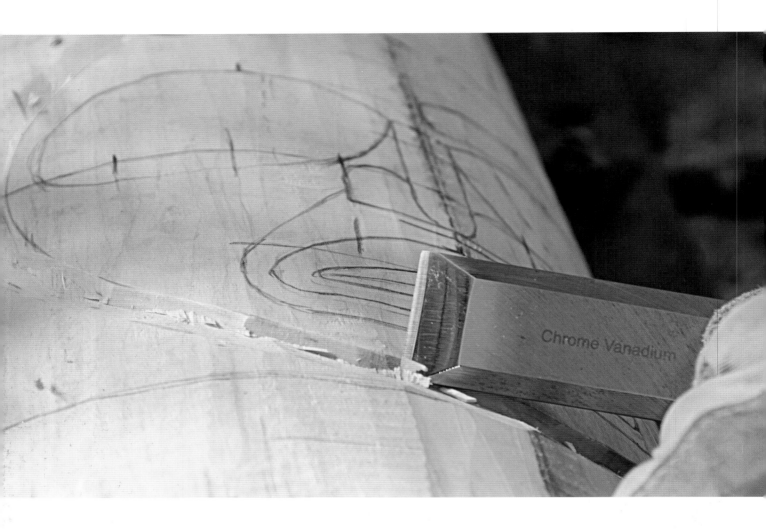

Most of the work at this stage will be done using the larger, 1 1/4-inch chisel. For narrower areas and finer cuts, use the smaller chisels.

If you find this kind of carving to be hard work, chances are that your tools are not sharp enough. It's also possible to have sharp tools that won't cut properly because the blade does not go straight back from the cutting edge, but is rounded. It's almost impossible to skim properly if the blade is rounded; similarly, a rounded blade on your hatchet will impede penetration when making a wedge cut. If necessary, grind your tools so that both sides of the blade sweep straight back from the cut edge.

The gouges come in handy when you're working on an area that will not be flat at the bottom of the cut – between the lips and the chin, for example, or around the eyes and in the recessed parts of ovoid shapes. You want to impart a curved shape to the wood, so it makes sense to use a curved tool. The smaller gouges can be used to make corners of mouths, or the tight curves of eyebrows, or to scoop out nostrils. The small gouge is also great for cleaning out the bottom of deep cuts.

When gouging around the eye, or making any other delicate cuts, remember not to make the sides of your cuts too steep. "No steeper than the pyramids" is a rule of thumb we teach our students. If you make these delicate areas too steep, you risk having pieces of wood break off.

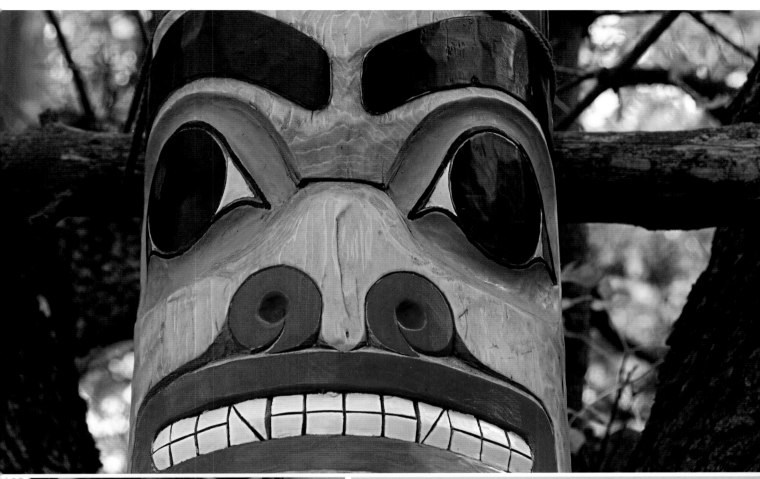

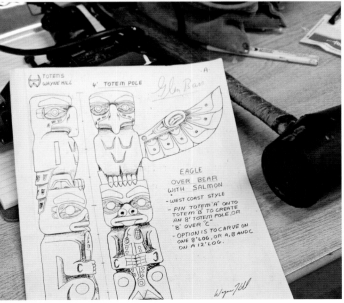

BACK TO THE DRAWING BOARD

Before moving on to the final stage of carving, it's a good idea to pull out the pencil again. By this time, all of the pencil marks you drew on the log will have been removed. The task of carving the fine, detailed lines that will make your carving complete will be a lot easier if you do the work with a pencil first.

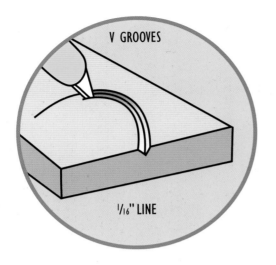

V GROOVES

1/16" LINE

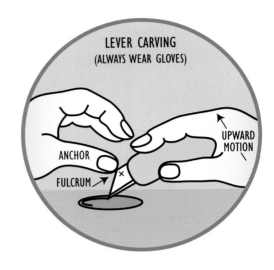

LEVER CARVING
(ALWAYS WEAR GLOVES)

UPWARD MOTION

ANCHOR

FULCRUM

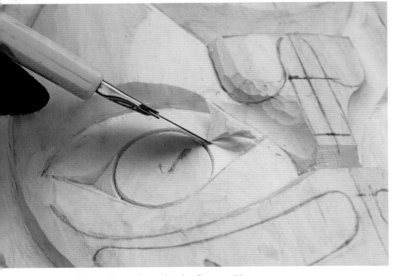

You will use the utility knife to cut V grooves (top photo) or to make other delicate cuts.

KNIFE WORK

Most of the fine carving will be done using the utility knife to cut V grooves. We discussed this technique in chapter 4, so pull on your leather gloves, and remember to keep those V grooves even.

If you find that you just can't get the hang of making V grooves with a knife, you may want to invest in a V gouge, which is sometimes known as a veining tool. The first time you try it you'll say, "Wow! Why wasn't this introduced earlier?" The reason we don't recommend a veining gouge is that they have a nasty tendency to *dive* when you least expect it, which makes your fine lines too wide in spots. Cutting your V grooves with a knife is a much more accurate technique, if you can manage it. If you have to use a veining gouge, work with a very light touch, going over your cuts several times rather than trying to make each cut in a single pass.

When doing the fine work, even and uniform lines are critical to having the piece look good. Once you've finished the fine work, stand back and look at it carefully, trying to see any spots where the lines are of unequal width. Remember, as long as you work slowly and gently, you will have several chances to correct your mistakes.

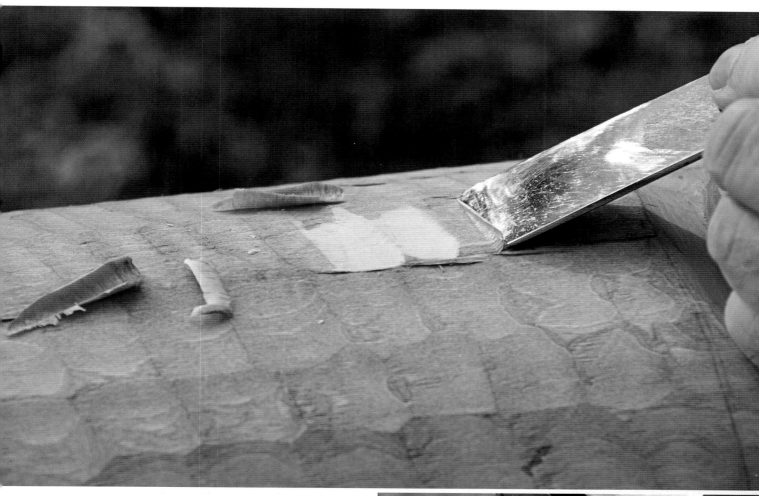

STIPPLING

This is a finishing technique that is optional but that adds great character and richness to the pole. Once you're finished carving your design, take your widest chisel and make square, shallow chip cuts all over the uncarved areas. Traditionally, Native carvers used a hand adze to do this. It takes a bit of practice to get it right, but the dynamic results are well worth it. Again, it's a technique that is best practiced on a piece of scrap wood.

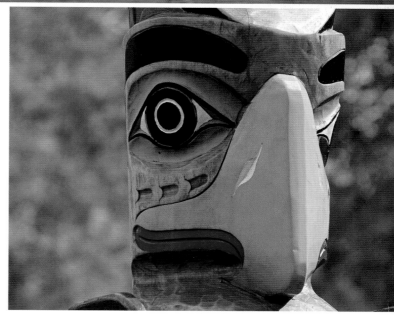

The above pole shows an example of stippling around the neck and head.

West Coast carving is a journey of V grooves which start with a point and end with a point. Like little rivers, they wind and swell, split into two and open up into V bottom lakes as they follow the design. If the lakes are wide, they acquire a round bottom.

Practice with these examples:

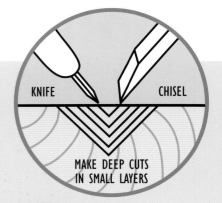

KNIFE CHISEL

MAKE DEEP CUTS
IN SMALL LAYERS

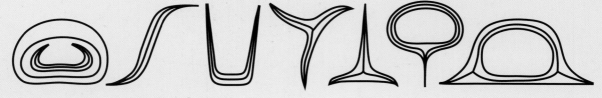

BASIC NOSE AND MOUTH PATTERNS

BEAR

ANIMAL

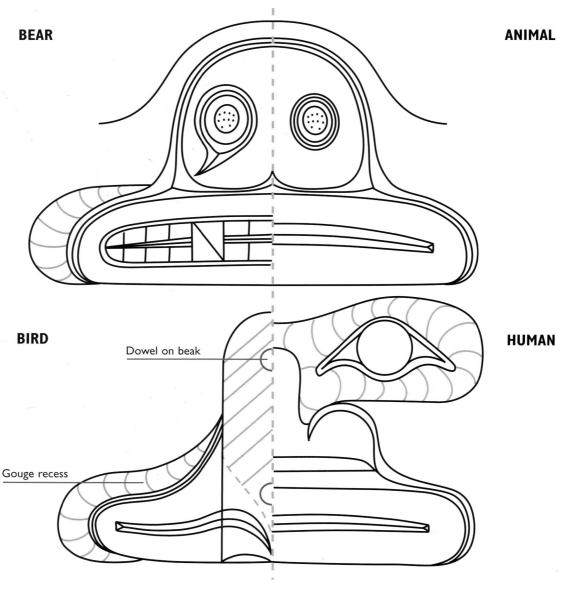

BIRD

Dowel on beak

Gouge recess

HUMAN

HUMAN

BEAR

or

or

WHALE

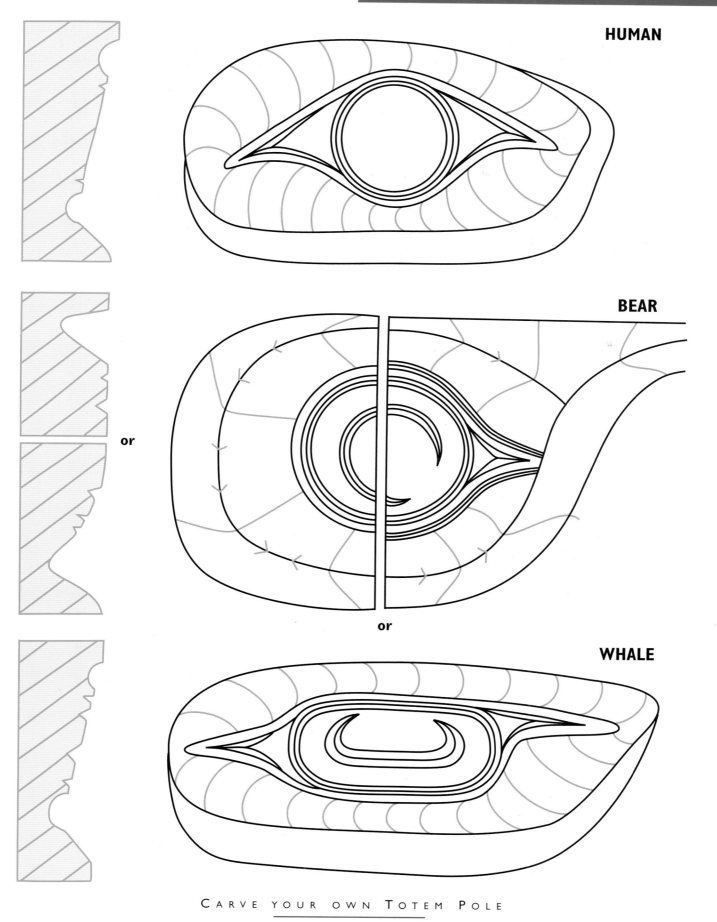

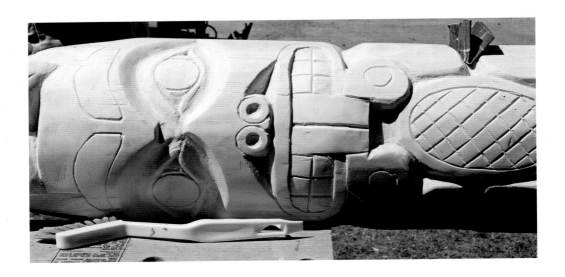

SANDING

Like stippling, the question of whether to sand is an entirely personal one. When we finished one of our first carvings, we spent hours going over the entire piece with sandpaper, carefully removing all tool marks. At the end of the process, somebody made a devastating remark: "Nice piece of plastic." Since then, we prefer to leave some visible tool marks on our carvings.

The works of some Haida carvers – including world-class carvers like Bill Reid and Robert Davidson – are incredibly smooth and look as though they've been sanded. They haven't: these carvers choose to go over their work making thousands of tiny, fine cuts to remove every trace of tool marks. Many other carvers prefer the more textured look that tool marks give. It's entirely up to you.

If you wish to emulate the smooth look of the Haida carvers, you may want to sand your work. That's fine. Just proceed slowly and gently, stepping back from time to time to look at your work. It's all too easy to reshape a finely carved face while trying to remove a tool mark.

PRACTICE, PRACTICE

In the space of a thousand words, we have just taken you through the entire carving process. Is that all there is? For basic, introductory carving, yes. When Wayne teaches carving courses at Sir Sandford Fleming College, he works almost entirely with novices who have never carved anything, let alone a totem pole. In just one week of classes, they achieve excellent results. The key is to take everything one step at a time, to go slowly, and to practice on scrap wood. Making the delicate chip cuts can be particularly tricky, but you'll be amazed at how quickly you get the knack when you practice on scrap wood first.

Take your time, and don't try to remove too much wood at once. Make your wedge cuts small at first – tentative, even. Yes, you'll make mistakes, but if you've not cut too deep, you can repair almost any mistake you make. Gradually, you'll find that the pole reveals itself to you.

KEEPING IT MOIST

In order to do your best work, you need to work with green wood. That's all very well when you start on a fresh log, but left untended, green wood very quickly becomes dry wood.

If you get a new log, and you're not going to start work on it right away, the treatment is very simple: apply a coat of stain to the cut ends and leave the bark on. Store it in a cool, sheltered, aboveground area, and it will remain fresh and green for at least six months.

When you're working on a carving, always try to work in the shade. At the end of work each day, spritz the log thoroughly with water, and drape a tarp or blanket over it. This will keep the log green and workable for at least a week.

But sometimes life gets in the way of a carving, and you need to take a longer pause. In that case, you need to seal the entire log with a coat of Sikkens Cetol #1 cedar stain, or whichever other stain you like to use. Let it soak in for five minutes, then wipe it off. When you return to carving, you'll simply cut away the stained wood, revealing fresh, clean wood underneath.

If you've finished carving part of the log and have reached the point where you would normally start sanding, it's best if you sand those sections before applying the stain. It will be very difficult to come back to the carving and sand it after applying stain.

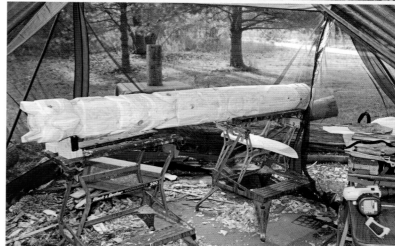

When you're working on a carving, always try to work in the shade.

Opposite – When sanding, proceed slowly and gently, stepping back from time to time to look at your work. It's all too easy to reshape a finely carved face while trying to remove a tool mark.

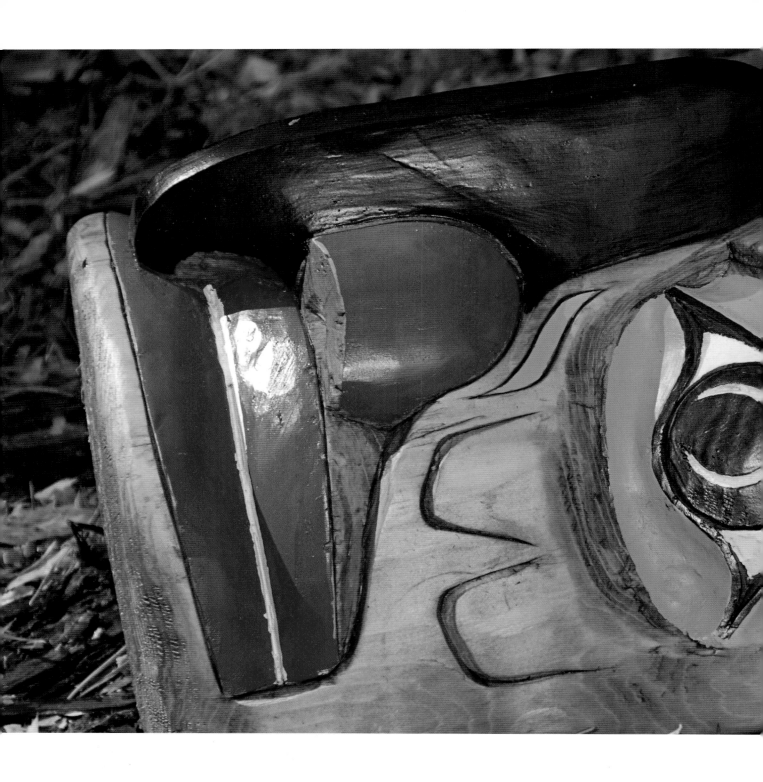

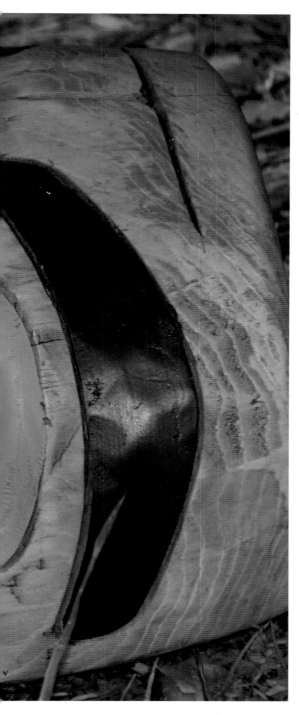

*Carving a mask is a great way
to practice your new skills.*

West Coast masks

Before you take on a full-fledged pole, you may want to try out all these new techniques on something a bit smaller. A West Coast mask is a great project to begin with. It involves all the skills you've learned so far – design work, using the hatchet, chisels, gouges, and knife – but applies them to a smaller and more manageable project. It also gives you a chance to learn another useful skill, – attaching outstretched moon rays. You'll use a similar technique on the larger pole, where you may wish to attach outstretched wings, as well as moon or sun rays.

Best of all, when you're done this project, you'll have your first piece of carved Native art, not just a practice piece but a piece that you can proudly display on the wall.

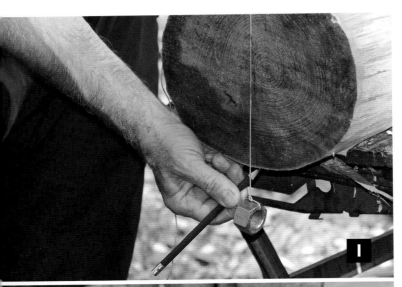

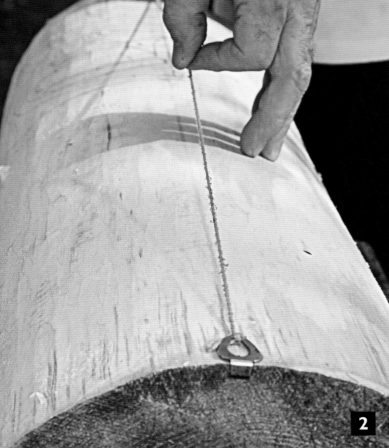

Assuming you are working from a full log, select the end of the log that you wish to use for your mask. Debark that area, but leave the bark on the rest of the log so it won't dry and crack before you're ready to use it. Leave the log in one piece while you carve the mask – the weight of the log will help to keep your mask steady while you work on it.

1 Turn the log until you find the side you want to work on. Use a ruler to draw a vertical center line, and mark the center of the log.

2 Then run a chalk line down the log to give you a center line. Using a compass, draw two circles to mark the outside of the mask: one the width of the log and another about 3/4 inch inside it. Because of the curvature of the log, your circles will appear to be elliptical.

3 Using your compass and ruler, mark a series of reference points on the vertical and horizontal axis, dividing the distance into eighths and marking each eighth with a small cross. Refer to the pattern on page 75 to see how these reference marks will help position your face and give it accurate proportions. The center of the eyes are one-eighth above the horizontal centerline and two-eighths away from the vertical centerline. The bottom of the nose is one-eighth below center, and the middle of the mouth is two-eighths below center. The top of the eye socket is two-eighths above center, and the top of the eyebrow is three-eighths above center.

4 With these reference points established, draw the outline of the eyes, the bottom of the nose, and the top of the mouth. These are the spots where you'll make the depth cuts, which determine the dynamic of the face.

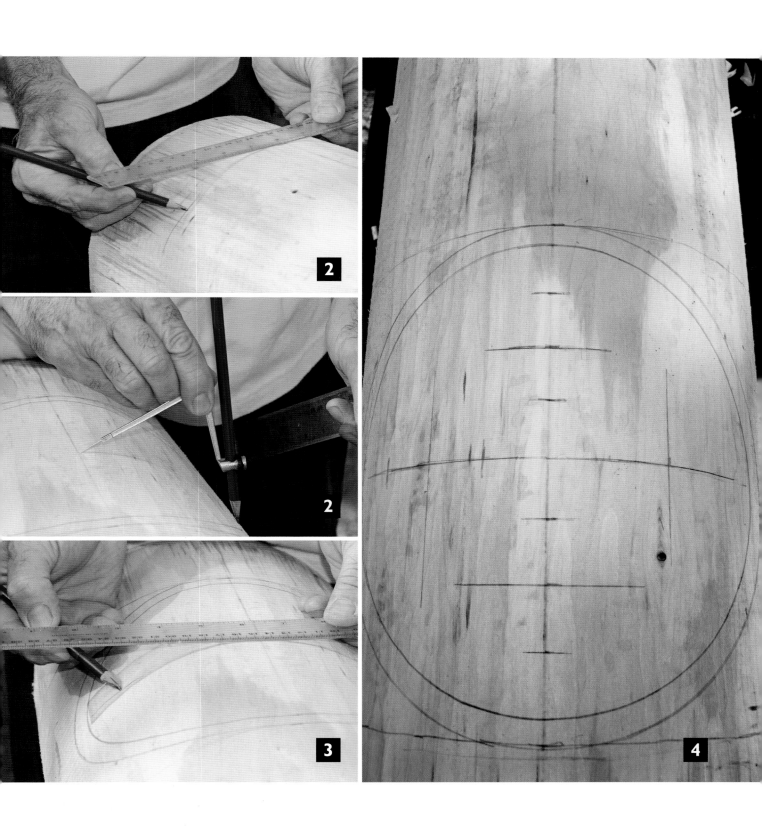

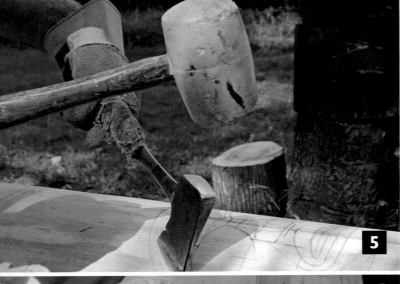

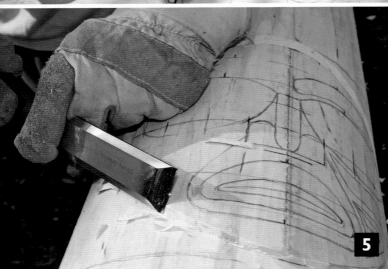

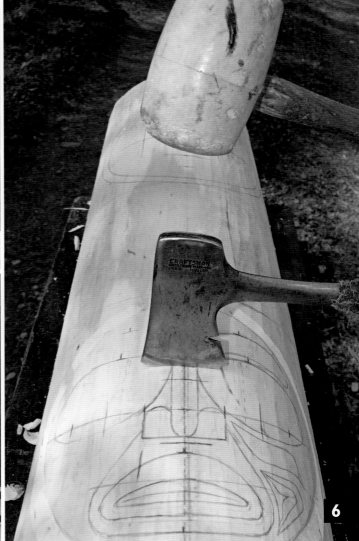

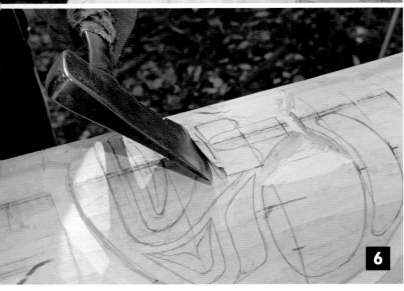

5 Use the hatchet and mallet to make a series of shallow angle cuts around the inside circle you drew with the compass, about $1/4$ inch to $3/8$ inch deep. Then go around the outside circle with a chisel, making another series of angle cuts, removing the wood as you go. This will define the outside of your mask.

6 Using the chisel and mallet, make wedge cuts at the side of the nose and slightly deeper wedge cuts at the bottom of the nose and side of the cheeks.

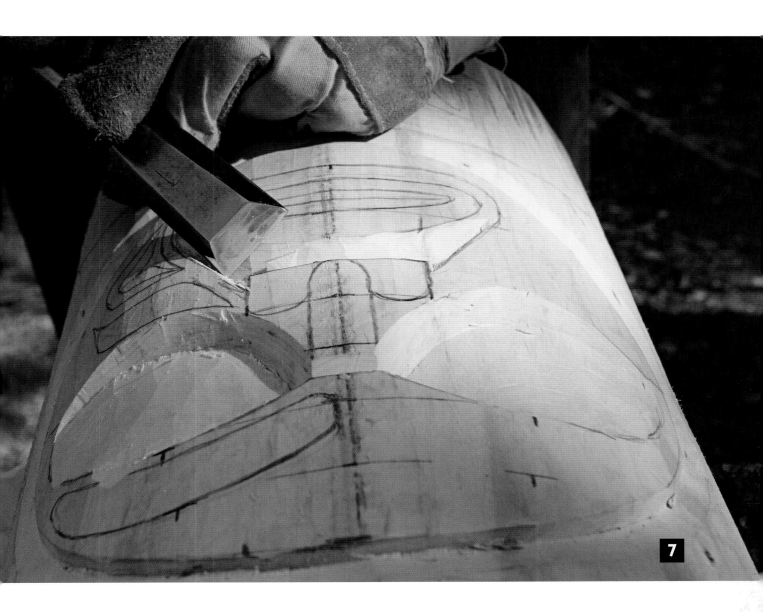

7 Use your knife or chisel to *release* the wedge cuts, skimming down from the top of the mouth profile to the bottom of the wedge cut you just made along the bottom of the nose. Do the same for the other wedge cuts.

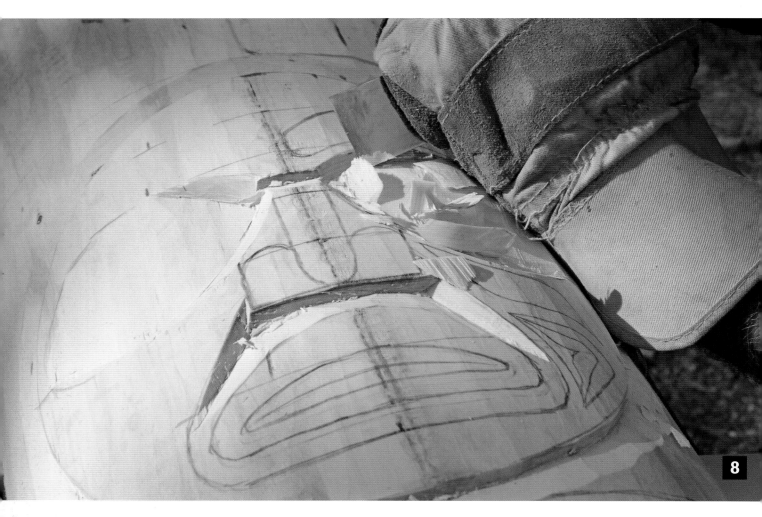

8

8 The basic depth cuts will now help you envision the shape of the eye sockets and mouth. Draw them on, then cut them out using a chisel. Experienced carvers will make the long, tapered wedge cuts of the eye sockets using a hatchet and mallet to rough it in, then using a chisel to skim it smooth. Until you get the feel for these cuts, though, it may be easier to carve the eye sockets with a chisel. Begin at the bridge of the nose and use the corner of the chisel to work your way down toward the eye itself. Then, making small cuts, skim down from the top of the eye outline to meet your cuts. Keep repeating this process until you've made the eye sockets as deep as you wish them to be. Remember, though, that the deeper you make these cuts, the more the nose and cheeks will be revealed.

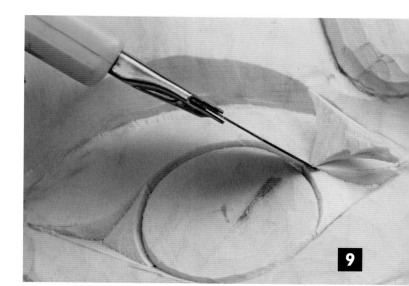

9 Now that you have a flat eye-socket area to work on, draw on the eye as shown. The basic shape is a circle with a split U on either side. Cut them out with the knife.

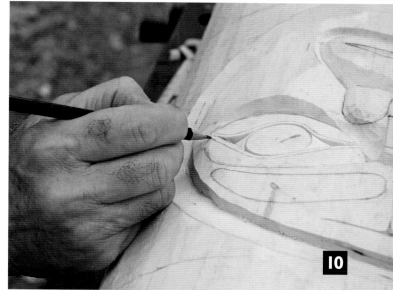

10 To define the eyes, draw a parallel line about 1/8 inch in from the eye outline. Using your gouge, carve a concave area around the eyes, from the eye outline to the eye-socket outline. Use your smallest gouge for the tight areas and a larger gouge where you can. This is one of those areas where tribal styles are revealed: Haida carvers will carry this gouged line down onto the cheek area, while other tribes tend to stop it at the edge of the eye socket.

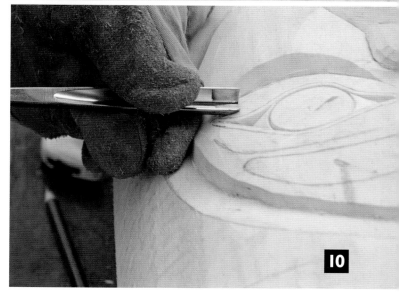

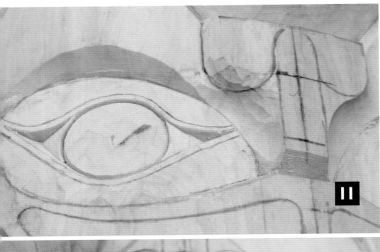

11 Draw on the nostrils, then use the knife to shape them with a fine V groove. Run a gouge up the side of the nose and blend the edges. Repeat this until there is a proper separation of nose and cheek. Do this without interfering with the flare of the nostrils.

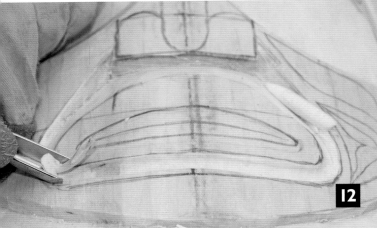

12 Gouge around the bottom of the mouth. Then use a knife or chisel to round off any areas that still need it.

13 To finish the design, draw on the additional elements — the eyebrows, the furrowed line at the forehead, the patches on the cheeks. Notice how all these are made up of the familiar shapes we looked at earlier — the split U, the S form, and so on. Spacing of these elements is very important, as these help to give your mask its character. Once you're satisfied with these elements, carve them using a knife to make V grooves.

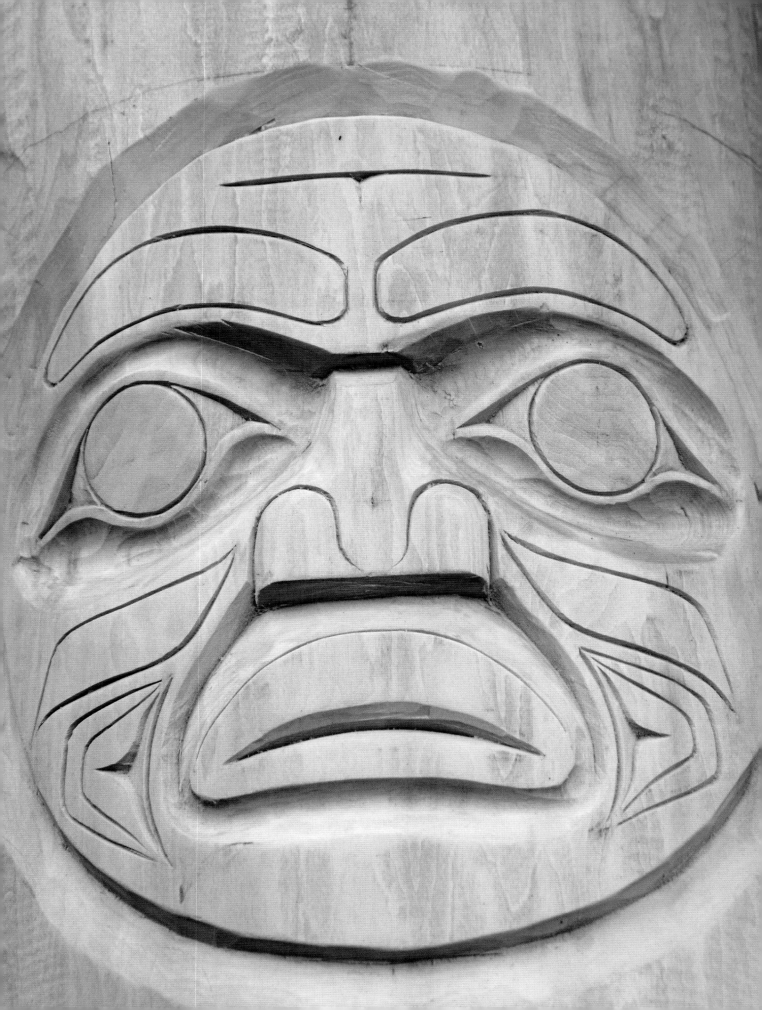

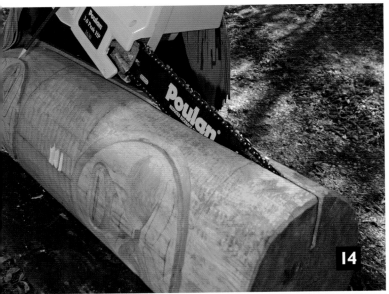

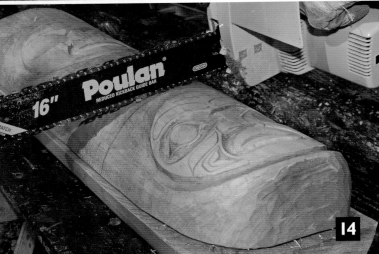

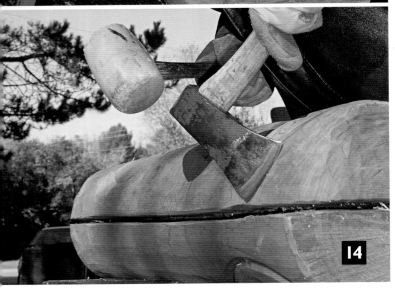

14 To release the face from the log, use a handsaw, band saw, or chain saw to cut down the log, cutting from the top first, then cutting across the log to release it. This will give you a rectangular piece of wood with a round face carved in it. The mask can be left this shape, or you can make it into a round mask by cutting around the outside of your initial circle, either with a band saw or with a series of hatchet cuts or chisel cuts.

 Skim the high spots with the chisel, and lightly sand any pencil marks and rough edges using 220-grit sandpaper.

15 If you wish to add rays to your mask, now's the time to do it. Use a jigsaw or band saw to cut four or five rays to the shape you desire. The length depends in part on personal taste and partly on where the mask is to be hung. Draw a simple design on each one – a U form and a split U make a nice combination – and carve them with a series of V grooves. Holes at the end can be cut with a hole saw (a handy and inexpensive device that attaches to a drill and cuts perfect holes), or a jigsaw. Screw the rays into the back of the mask, being careful of course not to drive a too-long screw through the front of your beautiful creation!

 For a more dynamic mask, make a circular back plate by clamping together several pieces of stock lumber until you've got a shape that is larger than your mask. Draw a circle that is slightly larger than your mask, and cut it out. Carve a pleasing design in it, and fasten it to the back of the mask. The rays are then fastened to the back of the back plate.

16 Brush any dust out of the grooves, and paint the mask if you wish. To finish it, simply rub on a coat of oil or stain, then wipe it off. Repeat when the first coat is dry.

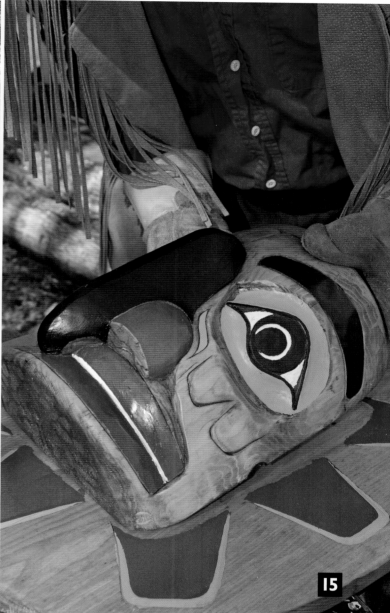

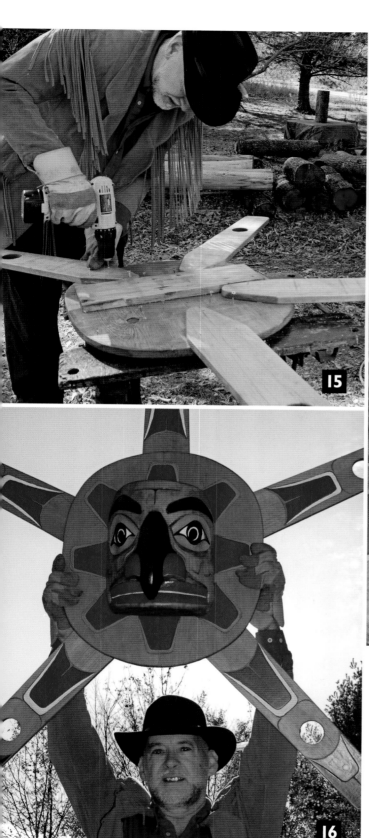

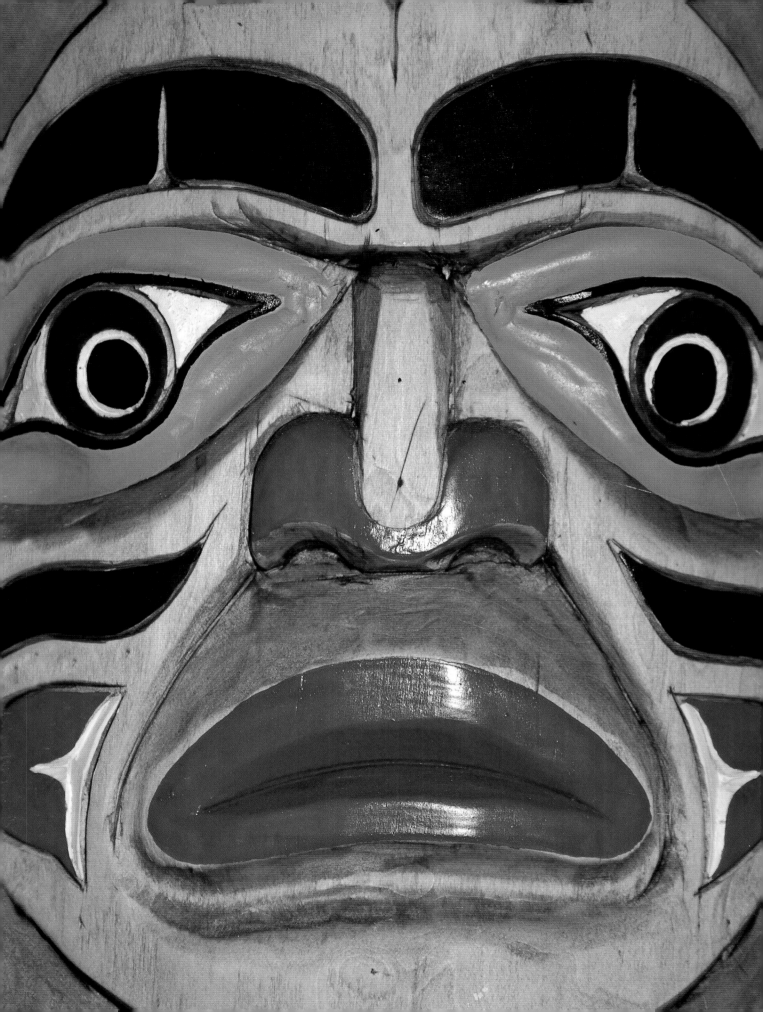

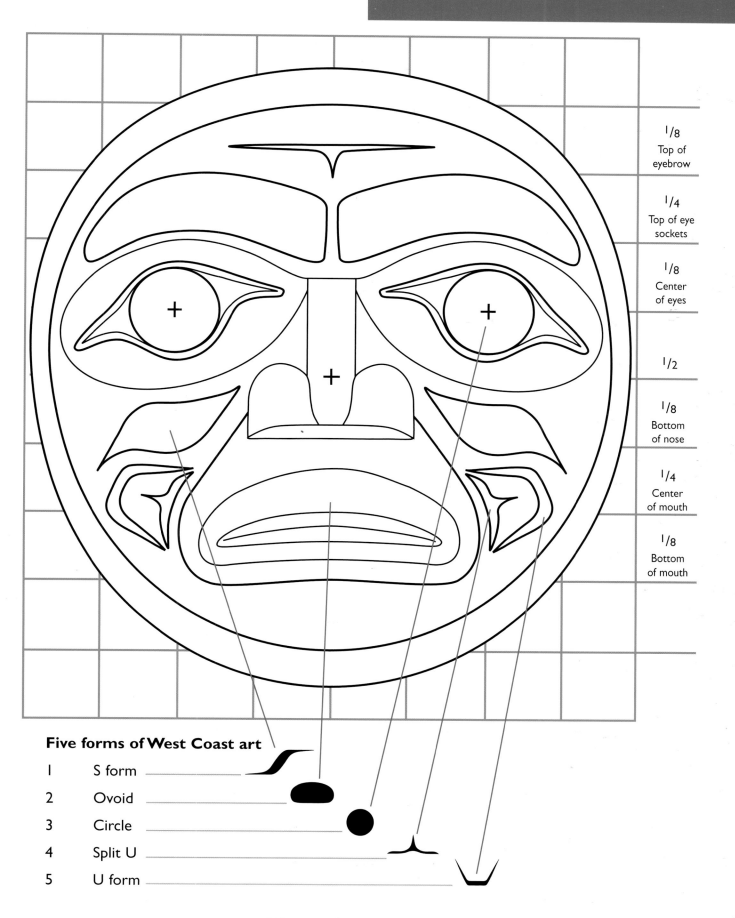

1/8
Top of
eyebrow

1/4
Top of eye
sockets

1/8
Center
of eyes

1/2

1/8
Bottom
of nose

1/4
Center
of mouth

1/8
Bottom
of mouth

Five forms of West Coast art

1	S form	
2	Ovoid	
3	Circle	
4	Split U	
5	U form	

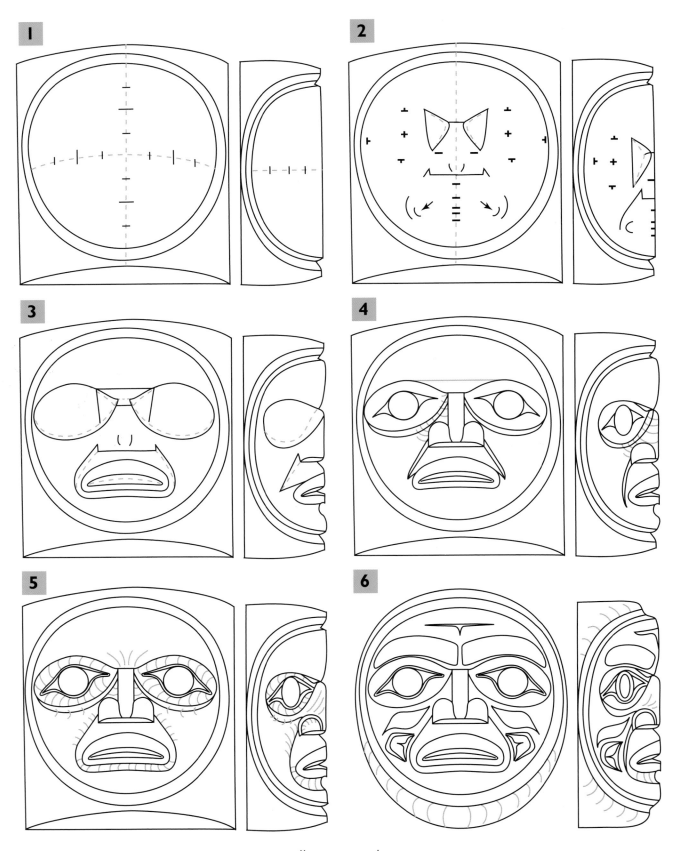

Note: not to scale

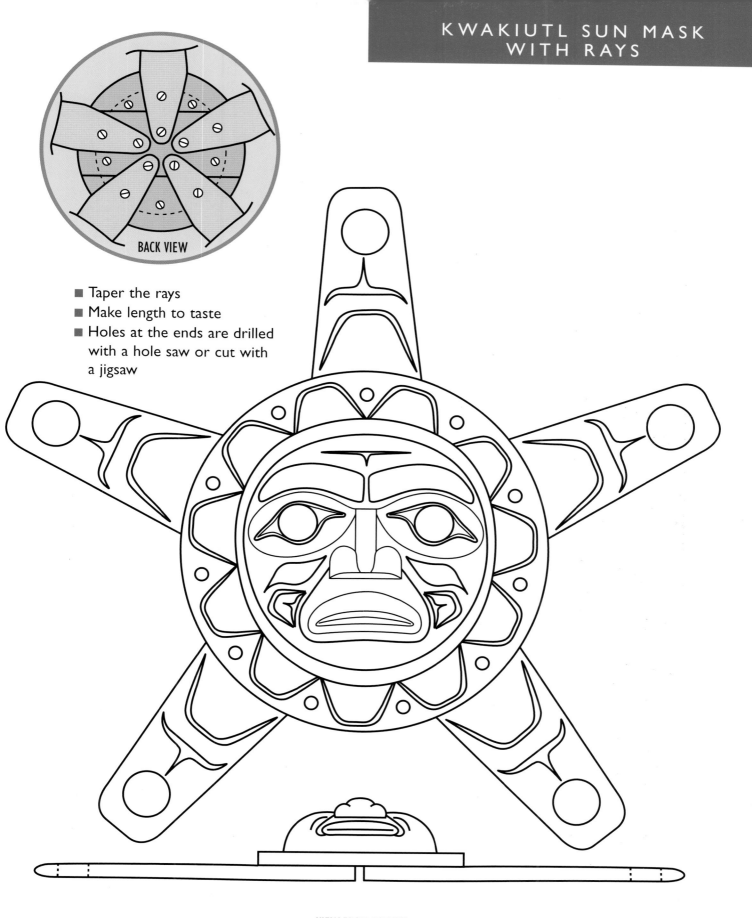

BACK VIEW

- Taper the rays
- Make length to taste
- Holes at the ends are drilled with a hole saw or cut with a jigsaw

VIEW FROM BOTTOM

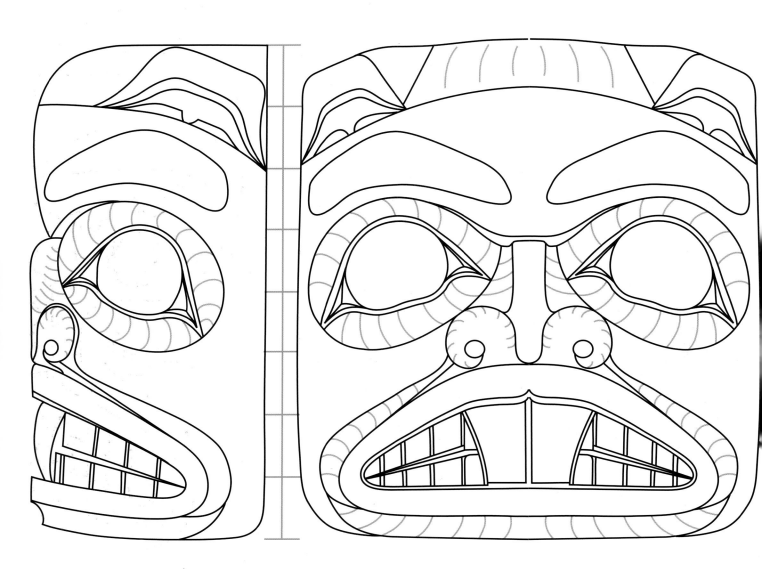

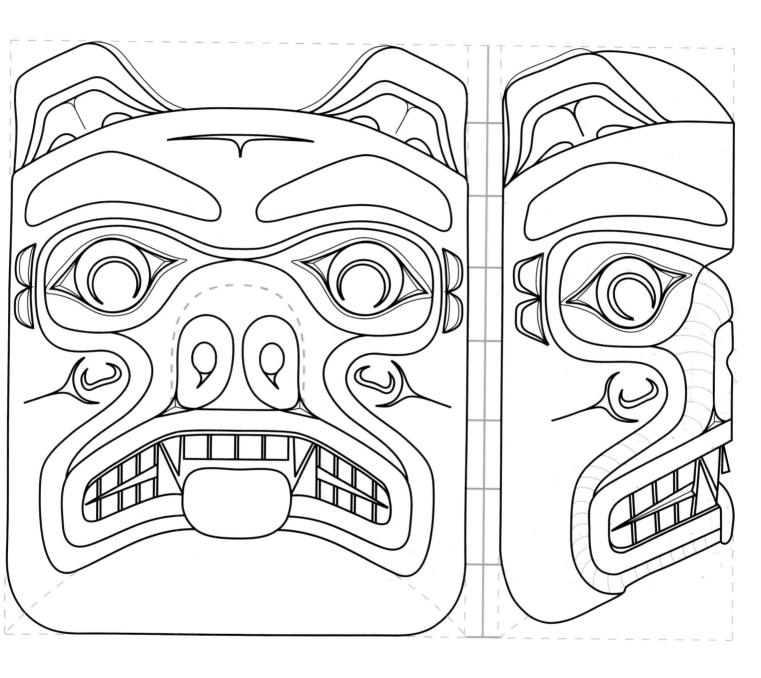

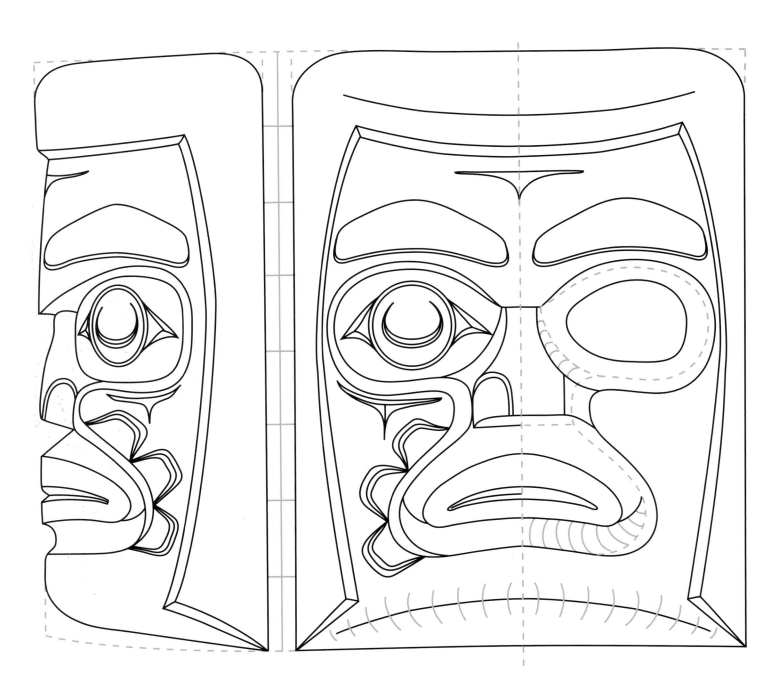

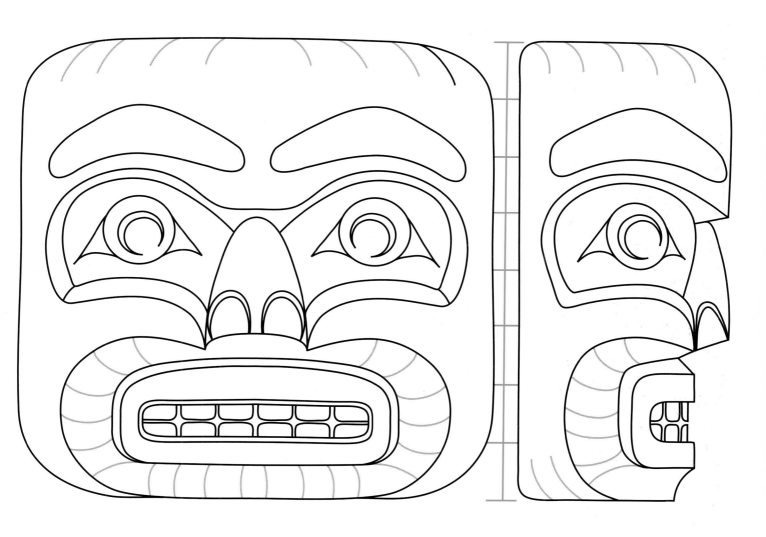

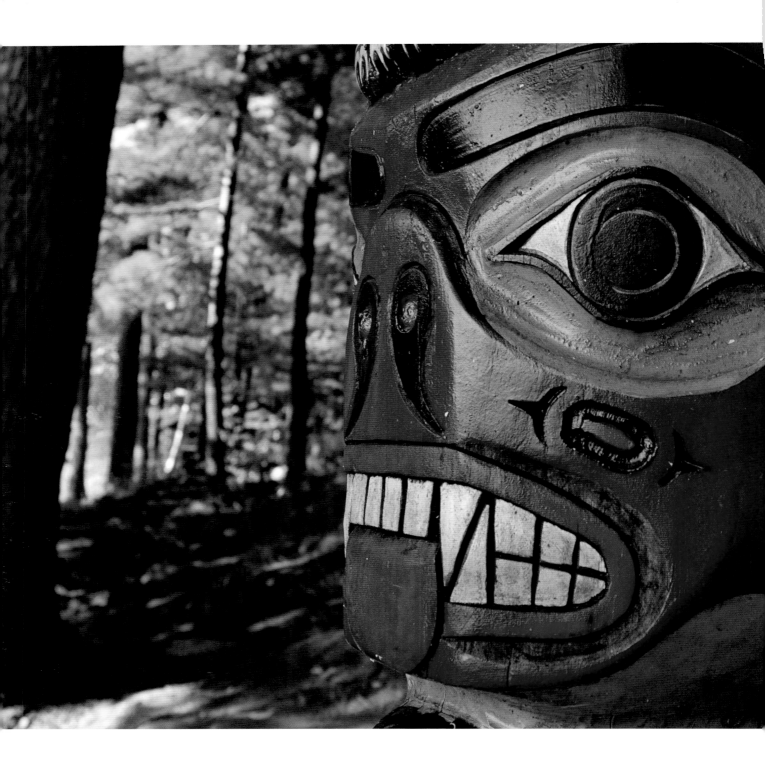

Carving a full-sized pole presents some unique challenges, but most of the techniques are ones you've already used to carve a mask. A four-foot pole is a good size to begin with.

Carving a pole

So far you've made at least one mask – perhaps several – and some two-dimensional carved works. Now you're ready to tackle the big project: a totem pole.

Totem poles can come in a wide range of sizes, from little 4-foot indoor poles that sit nicely in a living room to monstrous poles that tower 60 feet or more. Most of our customers like poles in the 8- to 12-foot range, which is a size that can be situated in nearly any environment and isn't too big to move.

When we teach classes, we often advise students to start with a 4-foot pole. This is a satisfying length to begin with, as it's possible to complete the pole in a week or so of steady carving. Some of our students come back year after year, carving a new 4-foot pole each time. When they're done, they can use steel rods to pin the pieces together to create a pole that is as long as they like.

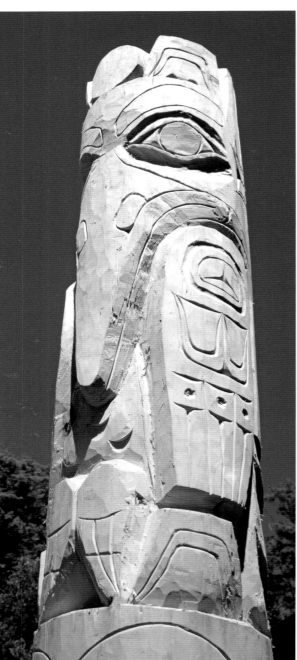

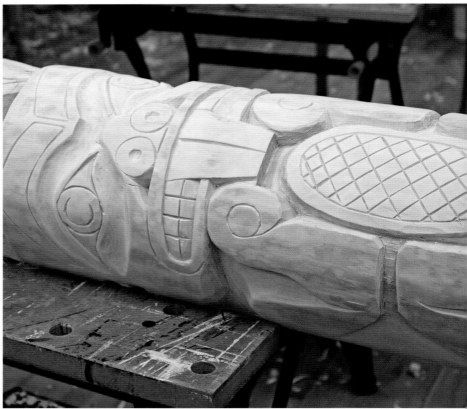

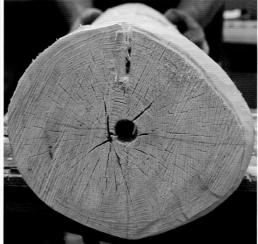

Students in Wayne's carving courses often arrive with no experience, but by the end of a week have produced poles like these.

To mount the pole, you will need to drill a hole in the bottom, 12 to 14 inches deep. Later on you can create a base for your pole with a piece of steel rod, which will slide perfectly into the bottom of the pole. In order for this hole to support the pole, it's important that you don't make the stress cut too deep.

PREPARING THE LOG

Before you can start carving, you need to debark the log. This is quite easy to do with a green log – use your hatchet and rubber hammer to lift a piece of bark. Then just pull the bark off in small strips.

Once the log is peeled, set it up on a pair of workmates, and begin to admire it. Since all logs taper, it will be pretty obvious which end is the bottom and which the top. You also need to find the front and back. There is always a good side and a bad side of the log face, and you want the good side for the front. Stand at one end, and turn the log around until you find the side that looks the straightest. That's the front. Once you've got the log sitting with the good side up, use a ruler to mark the center of one cut end. Then hold a plumb bob (or just a piece of string tied around a steel nut) against the center mark and mark the center of both the top, or front, of the log, and the bottom, or back. Do the same at the opposite end of the log. Then stretch a chalk line between the two marks to snap a center line. This will help you keep your design aligned. Roll the log over, and mark a center line on the back. Then cut along that line with a circular saw to make

a stress cut, to ensure the front of the log won't crack as it dries. Remember, the saw blade should be set to cut about a third of the way through the log – you want to leave the heartwood intact for the mounting bolt.

This is a good time to drill the hole for that bolt. For a 4- to-8-foot pole, use a $3/4$-inch auger bit. For a longer pole, use a 1-inch drill bit. You'll probably need to use a drill that's a bit heavier than the typical household $3/8$ inch drill – your local tool rental outlet will have what you need and a bit to match. With the log properly braced in place, use your chalk line to sight along the log so that the drill goes straight into the log. About 12 to 14 inches is sufficient. Later on you can create a base for your pole with a piece of steel rod, which will slide perfectly into the bottom of the pole.

With the front side of your log facing up, measure out reference points: one halfway from the bottom of the log to the top; two more at the quarter and three-quarter marks; then halve each quarter again so you have one reference point for every eighth of the log.

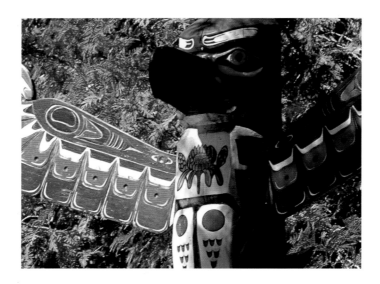

DESIGN

Go back to the sketch of a pole you designed in chapter 1. Now that you've done a bit of carving and painting, you may see things that you wish to change about that design. Now's the time to do it. Erase and redo until you're satisfied.

To transfer the design from your sketch to the pole, you need to make use of the reference marks you placed on the log. Draw similar reference marks on your design, dividing it into eighths just as you did with the log.

With the log clamped firmly in place, begin to copy your design onto the wood. One of the biggest challenges at this point is making both sides of the log balance – making eyes the same size, and making both sides of the mouth the same shape, for example. Cardboard patterns can be enormously helpful here. Draw an eye on a piece of thin cardboard – cereal boxes are ideal for this – and cut out the shape. Then you can trace around it on one side of the face and flop it over to get the exact same shape on the other side of the face. Eyebrows, mouths, and noses can all be done the same way.

If you don't like something about the design, don't worry. You still have time to change it. Just erase the lines and redraw it until you're satisfied. Then get hold of your newly sharpened cutting tools, and prepare to turn this log into a piece of art.

CARVING

The process of carving the log is exactly the same as the process of carving a mask. In fact, it may help if you look at the log as a series of short sections attached together, rather than as a unified whole. Begin at either end of the log, and decide how big a section you want to work on. You could carve an entire figure, or just do a face first before moving on to a body. Make your wedge cuts with the hatchet, use your gouges and chisels to shape the features, then use a knife to carve the fine V grooves.

Once you get to that point, simply move along the log to the next figure. Stippling, sanding, and painting should be left to the end. Not only is it easier to do the entire log at once, but you should never use carving tools (other than a utility knife) on a pole after it has been sanded. Fine grit from the paper remains embedded in the wood, and it can quickly dull your fine-edged tools.

Right – Naked welcome figures greeted people when they arrived at traditional Kwakiutl villages. This figure stands at the end of a driveway, usually wearing a kilt for modesty.

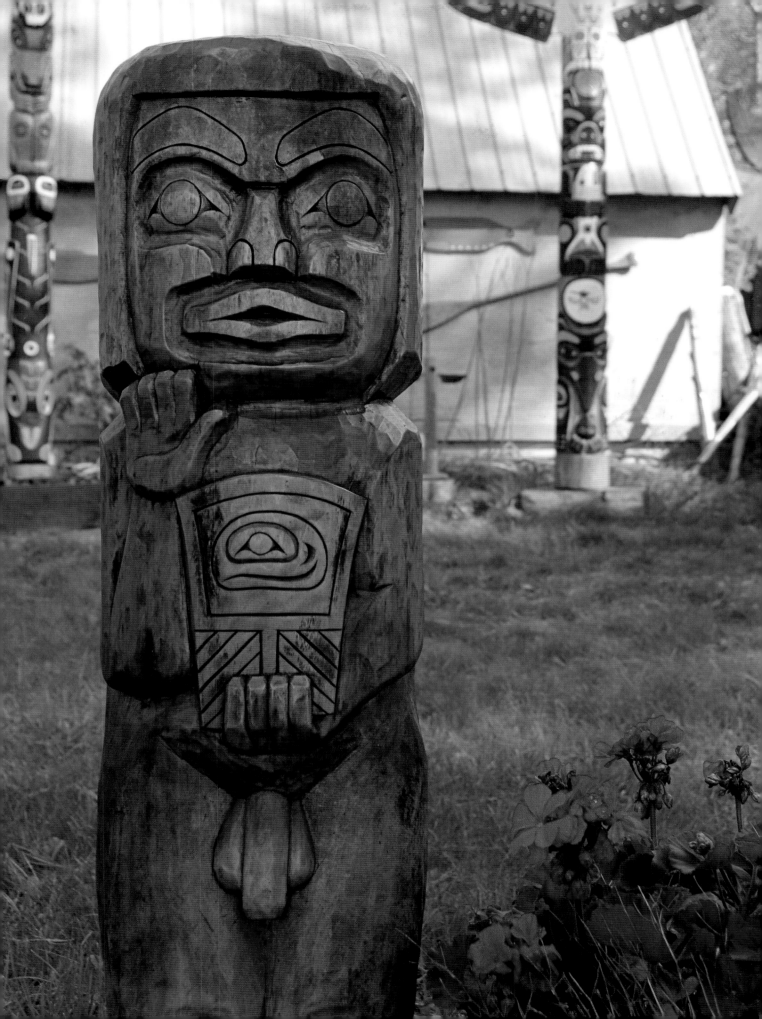

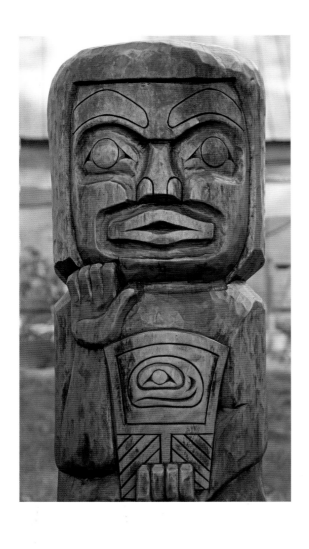

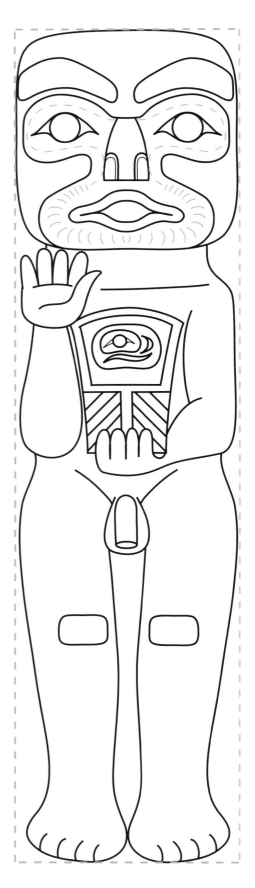

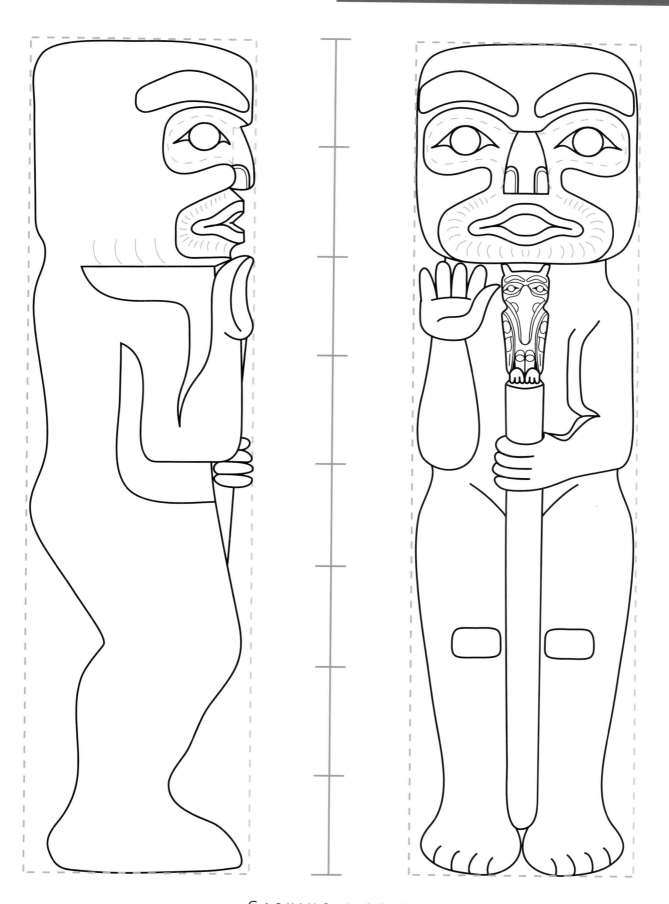

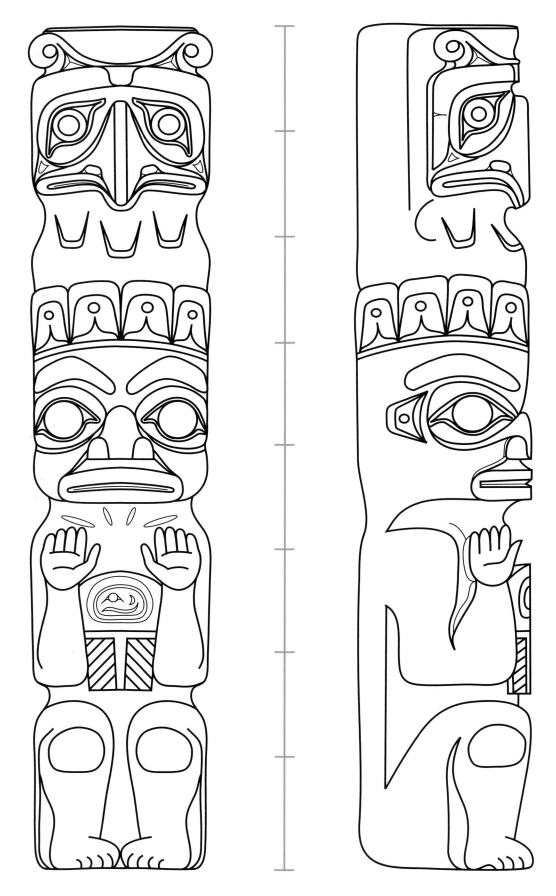

CARVE YOUR OWN TOTEM POLE

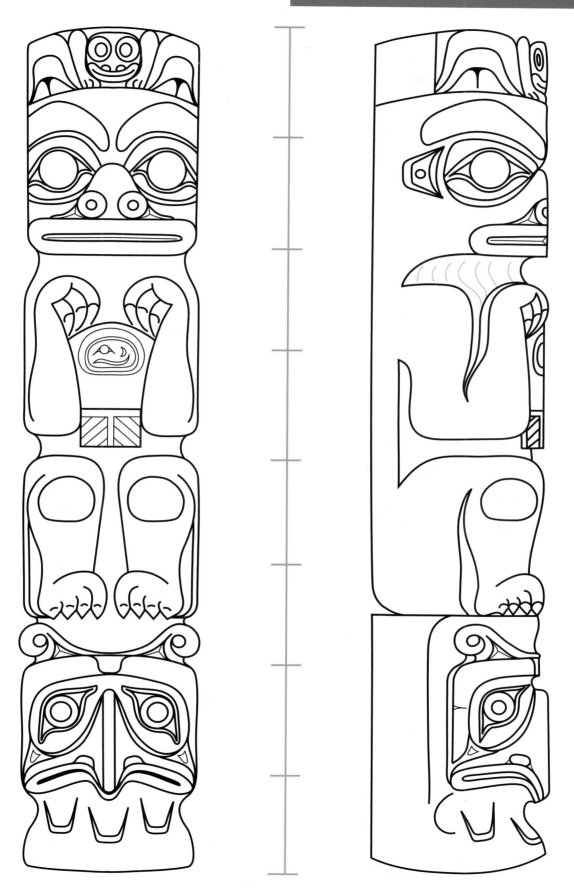

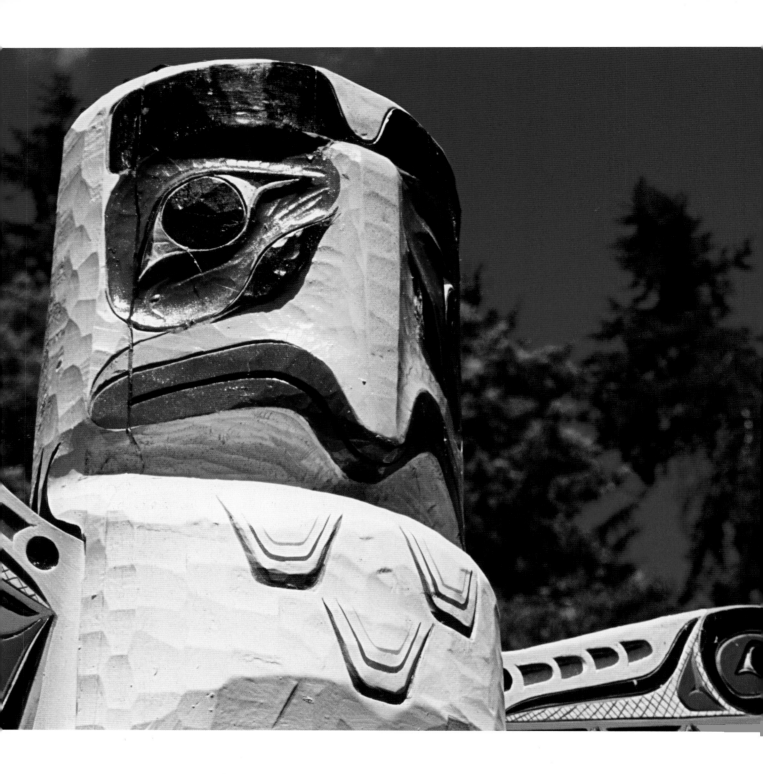

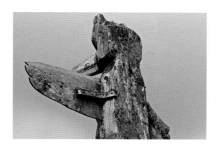

Wings, beaks, and outstretched arms

The outstretched wings of a thunderbird or the long beak of a raven can add greater dimension to a pole. Anything that isn't part of the original log will need to be securely fastened to it.

When designing your totem pole, there will come a time when you want to introduce an element that goes beyond the limits of a basic pole shape. Traditional poles often featured these horizontal elements such as the outstretched wings of a thunderbird coming out the sides, or the long beak of a raven protruding from the front of a pole. A modern pole design might feature a fishing rod or a hunting rifle, or you may wish to include a sun or moon with extended rays like the ones we put on the mask in a previous chapter.

The wood for these horizontal elements can come from a variety of sources. You may be able to purchase some more logs from your friendly firewood dealer. These can be cut into slabs about 2 inches thick, ideally by someone with a portable sawmill, if you can find one. Another option is to buy kiln-dried stock from a lumberyard, but if you're working in cedar you may find yourself paying as much for the wings as you paid for the entire pole log. A third choice is to make them from kiln-dried pine, also available from a lumberyard. It's much cheaper than cedar and weathers well. If you're painting the pole, it won't be at all obvious that you've used a different kind of wood for some parts of the pole.

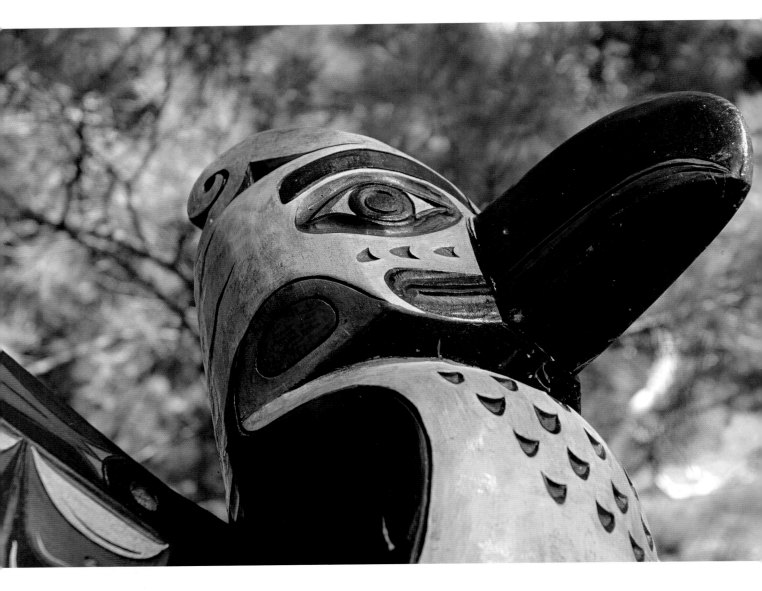

Carving wings and beaks is not difficult – it involves essentially the same techniques as are used to carve the main pole. But mounting them on the pole requires another step. The moon rays you made earlier could be simply screwed to the back of the mask, since it's designed to hang flat on the wall. That won't work on a vertical, free standing pole. To attach these horizontal elements to the pole, we need to borrow some techniques from cabinet-makers.

In this section we'll assume you're working on a beak, but the same techniques apply to wings, a fishing rod, or any other horizontal element.

To attach a beak to a pole, you have two options: dowels or a mortise-and-tenon joint. You should decide which you're going to use before you cut your beak to shape or start carving. If you're going to use a mortise and tenon, you need to leave some wood on the butt end of the beak, which can be cut into the tenon.

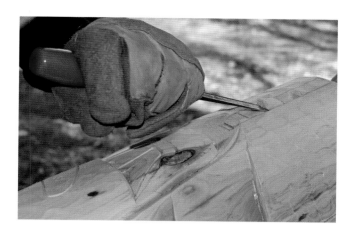

MORTISE AND TENON

A mortise and tenon is essentially a large, rectangular peg (the tenon) in a large, rectangular hole (the mortise). It's an ancient woodworking joint, used in everything from furniture making to barn building, and there are countless variations on it. The version that we'll be using is called a blind mortise, because the mortise isn't cut all the way through the wood.

Begin by cutting the tenon on the beak. The width of the tenon should be at least one-third the thickness of the stock you're working with, so if your beak is 3 inches wide at the point where it attaches to the pole, the tenon should be at least 1 inch wide. The depth depends on what you're attaching to the pole: outstretched thunderbird wings require a tenon that's at least 2 or 3 inches deep, in order to support their weight; an eagle's beak can be attached with a tenon that's only 1 1/2 inches deep.

Measure in from the end of your wood, and use a carpenter's square to draw the depth lines on all four sides of the stock. Then measure the height and width of the tenon, and mark those lines. Clamp the wood in a vice, and use a small handsaw to carefully cut away the waste wood from the sides of the tenon.

If you were making furniture or something else that involved using square stock, you could clamp all of your pieces together and use a square

to transfer the tenon dimensions to the mortise. But you're not working with square stock, so that's not an option. Instead, you'll need to hold your tenon against the pole and use a sharp pencil to trace its shape.

There are mortising tools available – special chisel bits that fit into a drill press and make square holes. If you have access to one of these, by all means use it. They're fast and accurate. If you're without a mortising machine, though, you can still make great mortises just as the old-time carvers and carpenters did – with a drill and chisel, or with a chisel alone.

If you're going to use a drill, start by marking the depth of the mortise with a bit of tape around the drill bit. The mortise should be at least 1/8 inch deeper than the length of the tenon, to ensure that the tenon doesn't hit the bottom of the mortise before the beak is fully in place. Drill a series of holes within the mortise outline you've penciled on the pole, being careful that your drill bit doesn't drift outside the lines. Then use a small chisel to clean out the rest of the wood. If you prefer, you can simply cut the entire mortise with the chisel. It's almost impossible to make the bottom of the mortise perfectly smooth, which is one reason you cut it a little bit deeper than the tenon length.

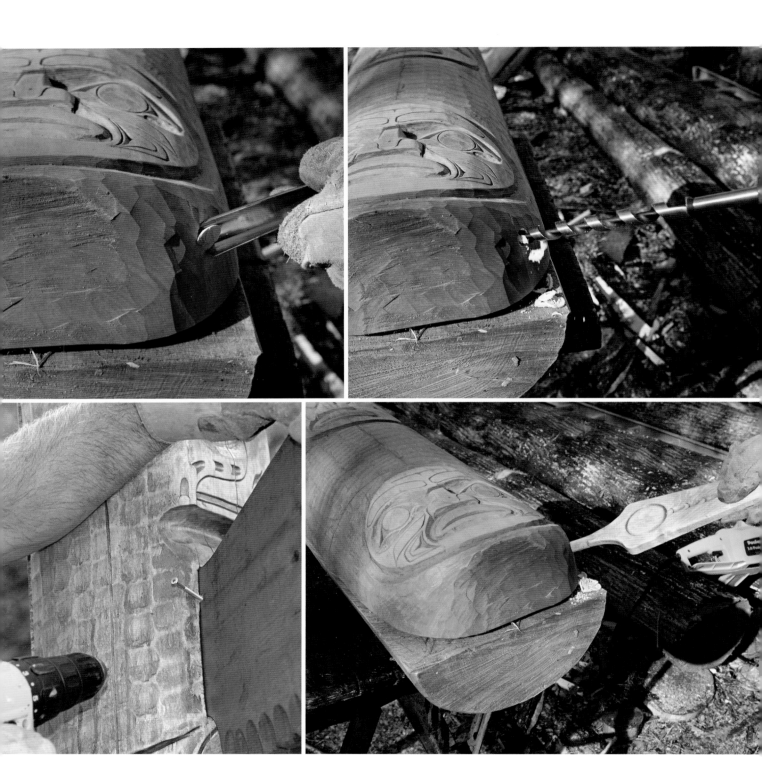

Top – Before drilling a hole in the pole or mask, it's a good idea to gouge out a small indentation. This will keep the bit from wandering when you start drilling.

Bottom left – Position the wing at the angle you want it. Then drive a 2-inch #6 wood screw through the back of the pole, drilling at an angle so the screw bites into the top of the tenon.

Bottom right – The dowel or tenon should fit snugly but not be so tight it needs hammering. Twisting it slightly as you insert it will help.

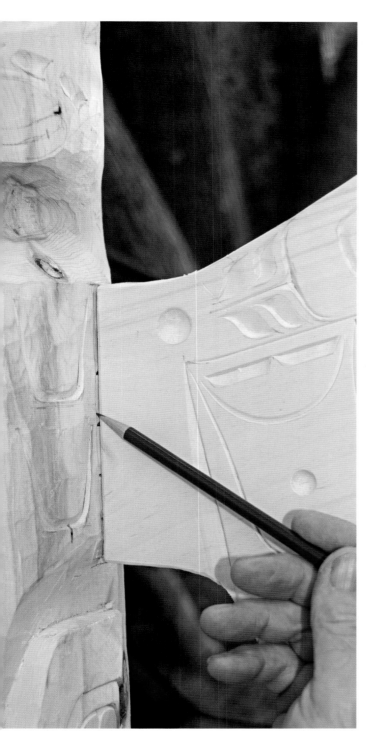

Insert the tenon into the mortise. It should fit snugly but not be so tight that it needs hammering. You may need to trim, adjust, and shave here and there to get it fitting right. You will want to leave a little wiggle room in the bottom of the mortise, so that the angle of the wing can be adjusted to ensure that both wings line up properly.

Once you're satisfied with the fit, lay out the beak, the wing, the moon ray, or whatever it is you've been working on, and carve it. If it's a beak or some other element that is mounted on the front of the pole, then you should put a bit of carpenter's glue on the tenon before sliding it into the mortise. If any oozes out, wipe it up immediately.

If you're mounting a wing, arm, or something else on the side of the pole, then you can take advantage of the fact that the pole has a back. Position the wing at the angle you want, then drive a 2-inch #6 wood screw through the back of the pole, driving it at such an angle that the screw bites into the top of the tenon. If it's a really large element, you can put a second screw near the bottom.

Then stand back and admire your workmanship. Take a long time to admire it, because this is one of those elements of the pole that nobody else is going to remark on. If you've done your job well, no one will even notice that you've cut a perfect mortise and tenon. You'll just have to take quiet satisfaction in the knowledge.

You will want to leave a little wiggle room in the bottom of the mortise, so that the angle of the wing can be adjusted to ensure that both wings line up properly.

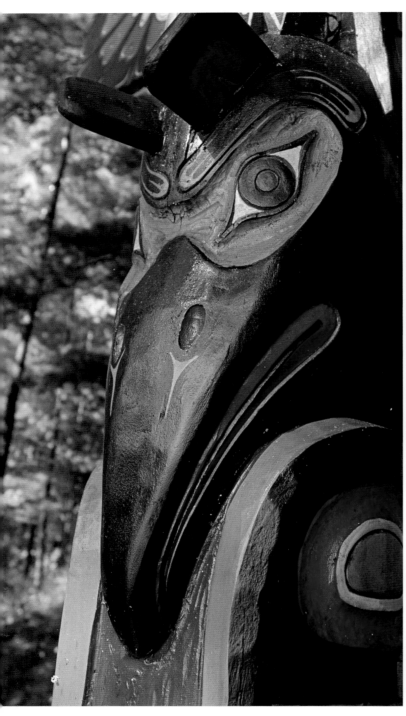 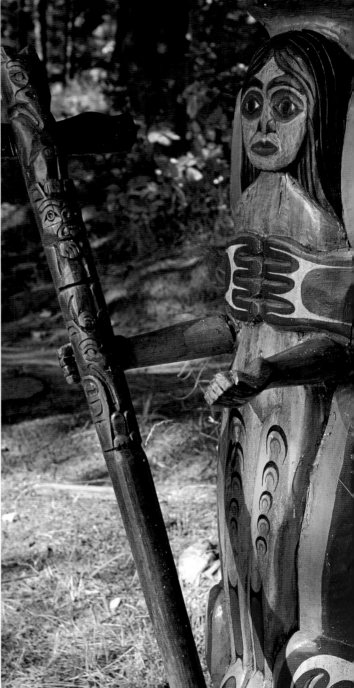

Dowels are an appropriate way to attach small, light elements such as eyebrows or smaller arms. If more support is needed, it's best to carve a mortise and tenon.

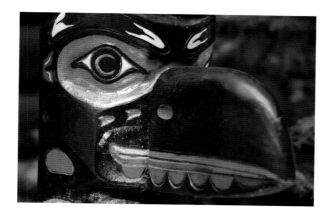

DOWELS

The other option for attaching horizontal elements to your pole is to use dowels, – slender, round rods of hardwood. These are best used for smaller elements, such as beaks, as they are not as strong as a well-made mortise and tenon and might not support a thunderbird's wing.

To peg or dowel two pieces together, you need to drill matching holes in the pole and the beak, then slip dowel a into each hole. The key is to ensure that the hole in the beak and the hole in the pole are drilled at the same location and the same angle.

Begin by drilling the holes in the beak. To ensure they are drilled at a perfect 90-degree angle, you can use a drill press if you have one. If not, pick up a handy device called a doweling jig – available at most hardware stores for under twnety dollars, it is designed to center your holes on the piece and help hold the drill bit at the right angle. Use a piece of tape around the drill bit to set the depth – an inch is about right. Two dowel holes should be sufficient.

You can buy precut doweling pegs, but they're made for working with dry wood. You're working with green wood, which will shrink as it dries. The dowels, however, are hard and dry and won't shrink, so if you use regular, store-bought

dowels, you risk having the green wood crack as it tries to shrink around the unyielding dowel. So what you need to do is make a square peg for your round holes. Buy a length of hardwood dowel, and run a hand plane along four sides. Then cut the now-square dowels to length and insert them. They will bite into the green wood on the corners but will still leave some contraction room for the wood to dry.

To get the holes in the right place on the pole, rub a little chalk on the ends of the dowels. Then press them against the pole where you want the beak to be. Use your drill press or your doweling jig to drill the matching holes in the pole, and check that everything lines up as it should. Then start carving the beak.

Be sure to do all your doweling before you start carving. If you have trouble getting the dowels to line up, in a worst-case scenario you can toss out the chunk of wood that will become a beak and begin the doweling process with a fresh piece of wood. That's a lot more painful if you've already carved the beak.

When you're ready to attach the beak to the pole, use a dab of glue just as you would with a mortise-and-tenon joint.

CARVED BEAK

Not all birds have a beak that protrudes beyond the dimensions of the log. To carve a beak as part of the bird's face:

- Rough out with wedge cuts using carving hatchet and mallet
- Shape with carving
- Draw on knife-cut designs
- Gouge under beak and around eyes. Use gouge to make feather designs around beak

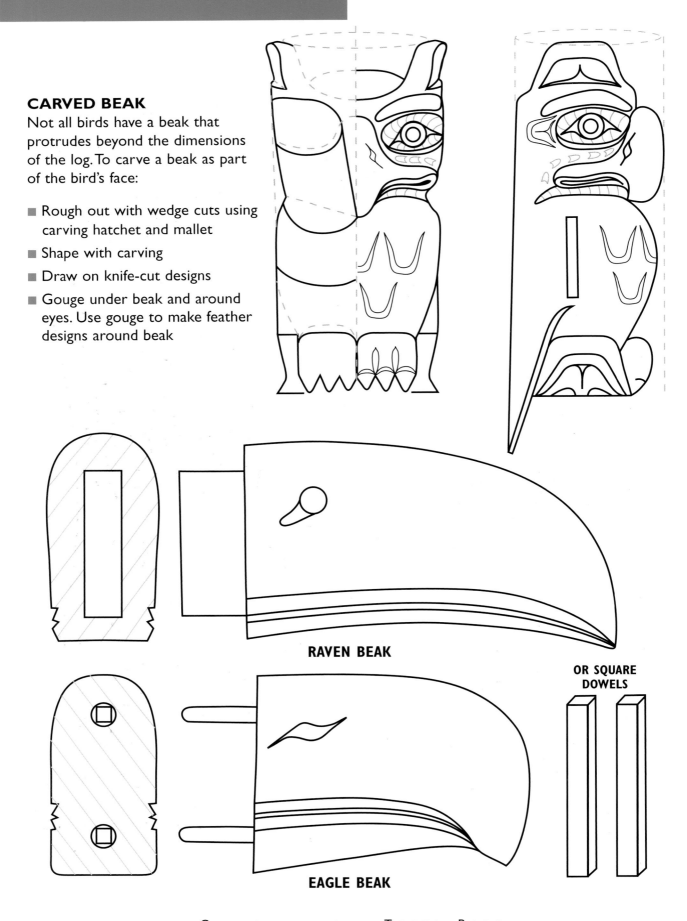

RAVEN BEAK

OR SQUARE DOWELS

EAGLE BEAK

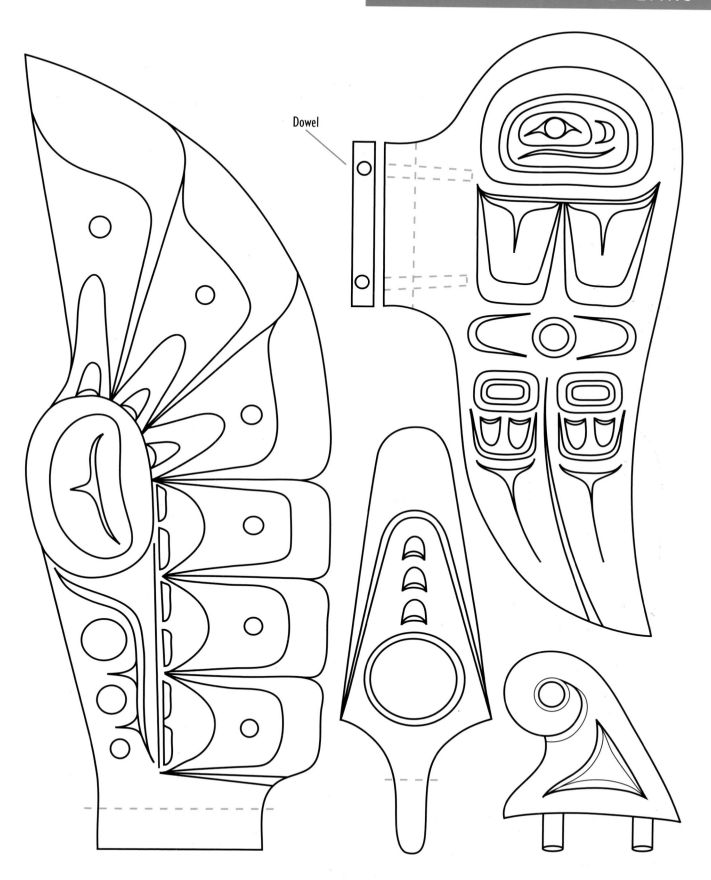

Dowel

WINGS, BEAKS, AND OUTSTRETCHED ARMS

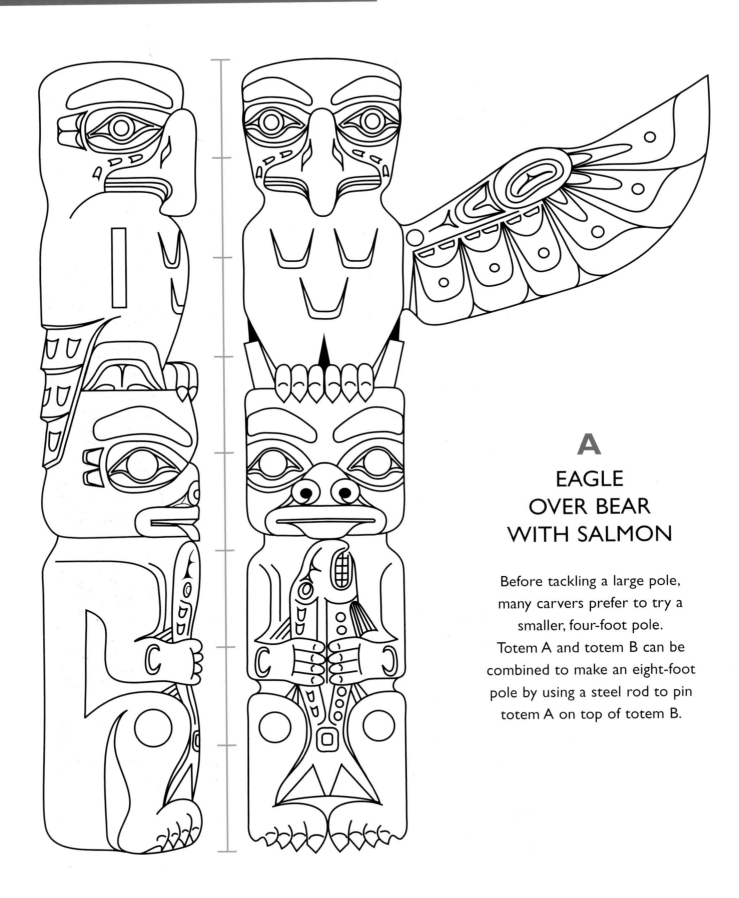

A
EAGLE
OVER BEAR
WITH SALMON

Before tackling a large pole,
many carvers prefer to try a
smaller, four-foot pole.
Totem A and totem B can be
combined to make an eight-foot
pole by using a steel rod to pin
totem A on top of totem B.

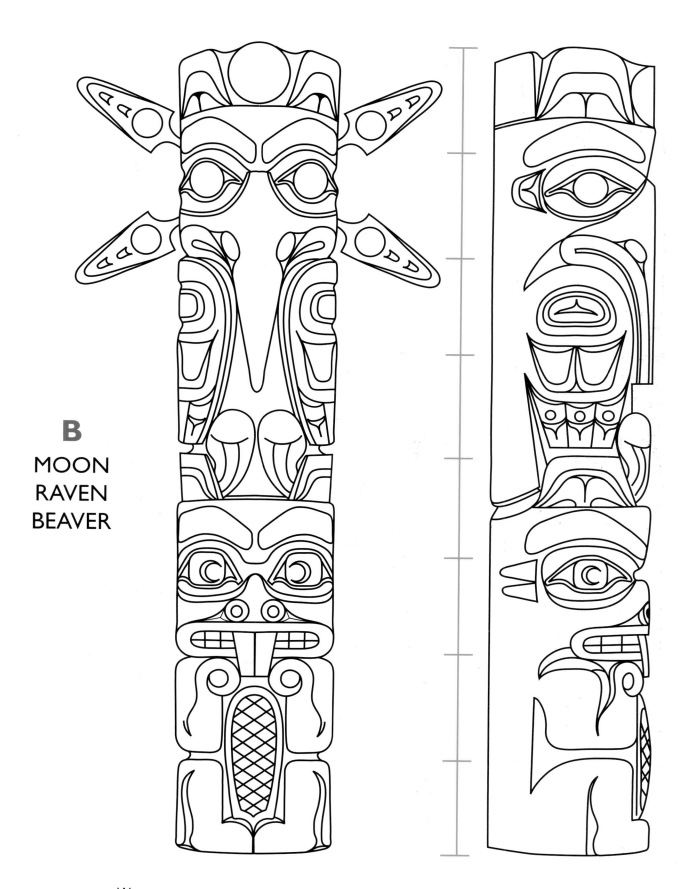

B

MOON
RAVEN
BEAVER

WINGS, BEAKS, AND OUTSTRETCHED ARMS

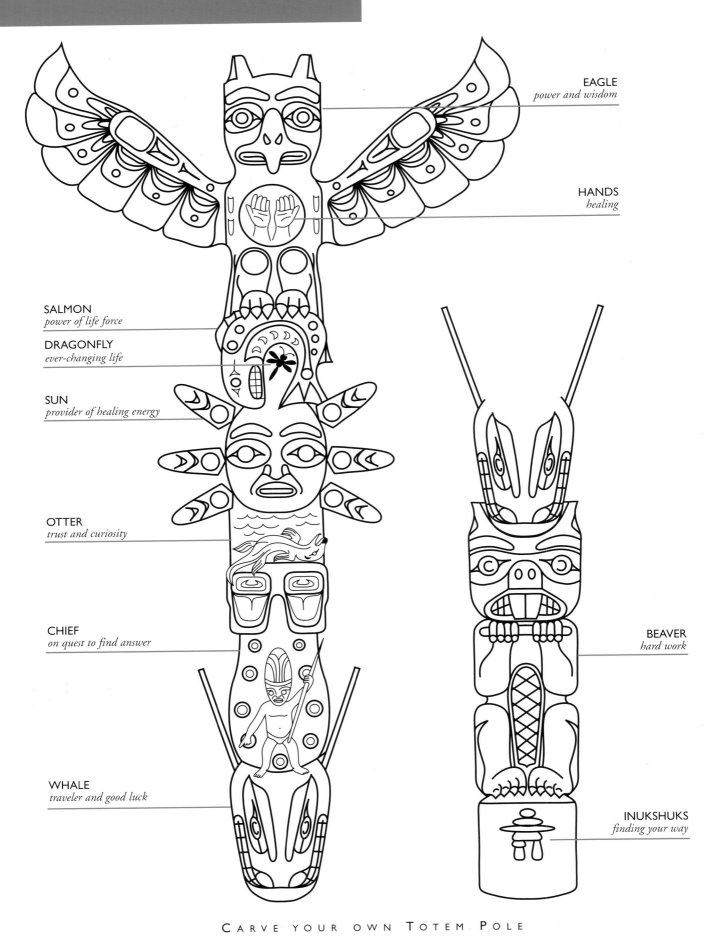

EAGLE
power and wisdom

HANDS
healing

SALMON
power of life force

DRAGONFLY
ever-changing life

SUN
provider of healing energy

OTTER
trust and curiosity

CHIEF
on quest to find answer

WHALE
traveler and good luck

BEAVER
hard work

INUKSHUKS
finding your way

CARVE YOUR OWN TOTEM POLE

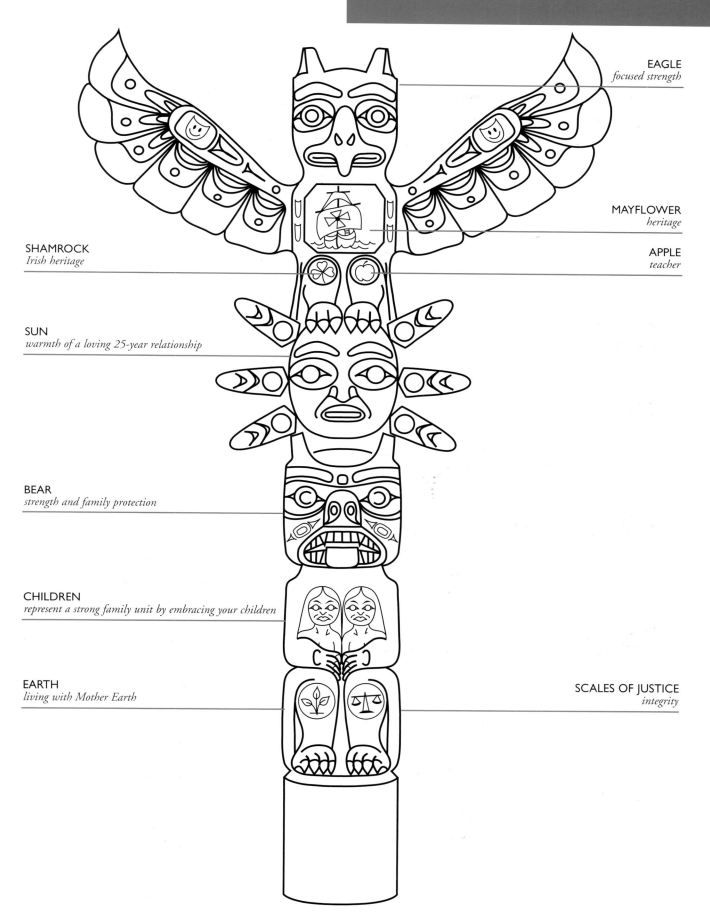

EAGLE
focused strength

MAYFLOWER
heritage

APPLE
teacher

SHAMROCK
Irish heritage

SUN
warmth of a loving 25-year relationship

BEAR
strength and family protection

CHILDREN
represent a strong family unit by embracing your children

EARTH
living with Mother Earth

SCALES OF JUSTICE
integrity

WINGS, BEAKS, AND OUTSTRETCHED ARMS

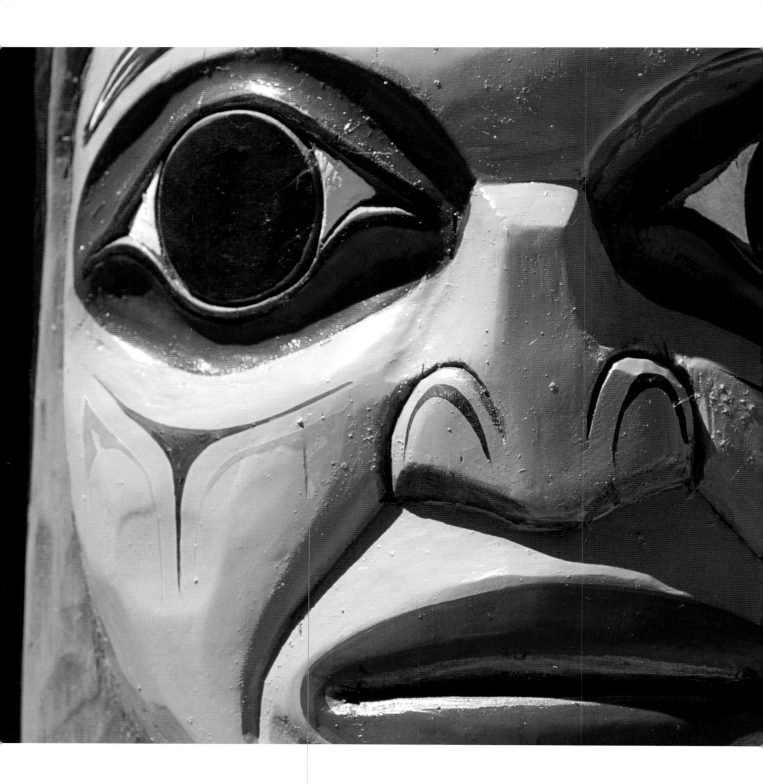

Painting and sealing your pole

The question of whether to paint your carving or leave it natural is an entirely personal one. Among traditional West Coast carvers, the practice surrounding paintings on poles varies from tribe to tribe – the Kwakiutl people, for example, use a few more colors than Haida carvers. Many of the oldest poles found on the West Coast are gray and weathered, but it is believed that they, too, were once painted and have simply lost their colors to the wind and the rain.

Regardless of whether you choose to paint or not, you will almost certainly want to treat your pole to preserve it. For many years, the Native carvers of the Pacific Northwest carved their poles and stood them outdoors with no protection at all. They were protected by the marvelous natural preservatives of old-growth cedar, and the carvings are recognizable many years later. You, however, are unlikely to be using old-growth cedar. Besides, you don't just want your carvings to be recognizable; you want them to look sharp and crisp for as long as possible.

There are a number of wonderful wood preservatives on the market, each of which performs differently. All will change the color of wood – even painted wood – so it's best to test your wood preservative on a scrap of leftover wood to ensure you like the way it looks.

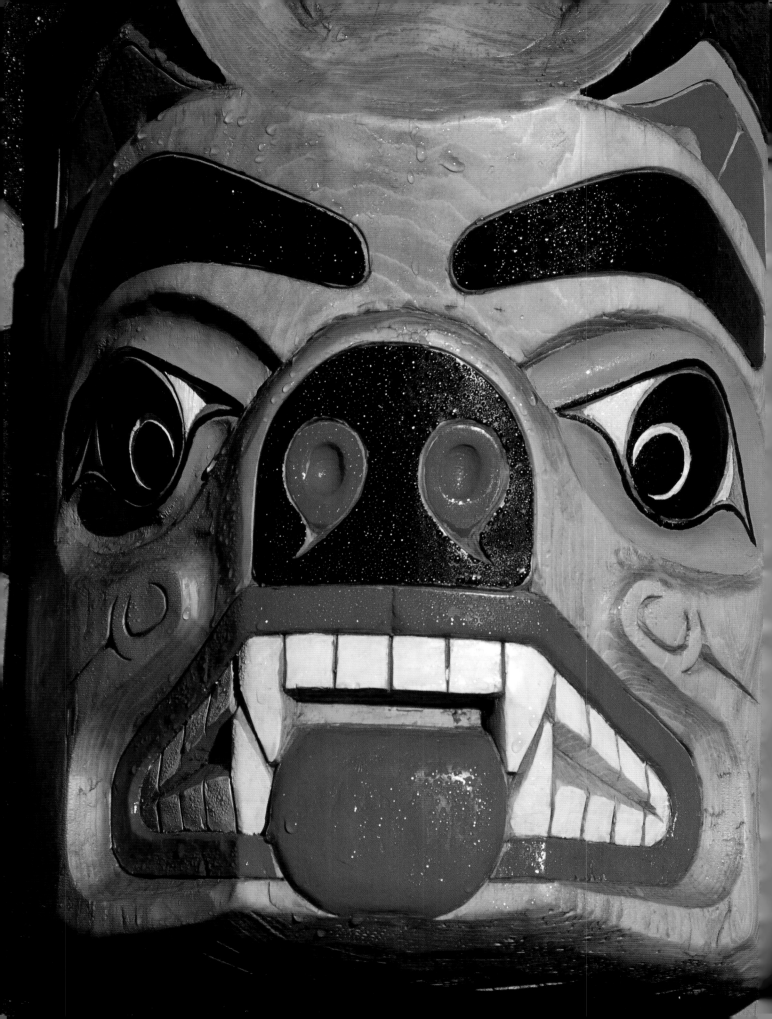

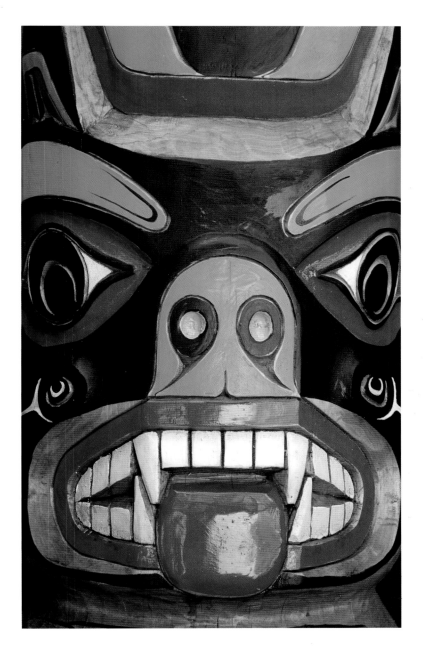

There are a number of wonderful wood preservatives on the market, each of which performs differently. All will change the color of wood – even painted wood – so it's best to test your wood preservative on a scrap of leftover wood to ensure you like the way it looks. We prefer to use Cetol #1 by Sikkens, because it works well and we like the way it makes the wood look, but many other products work just as well. Cetol imparts a burnt, umber color to the wood. To use it, you simply brush on a coat, leave it for five minutes, then wipe it off. Give a new pole two coats and it will last for years; treat it annually and it will last for generations.

If the pole has been painted, be careful not to leave any pools of Cetol residue in the corners and low points of your carving, as it will impart a yellowish color to the paints.

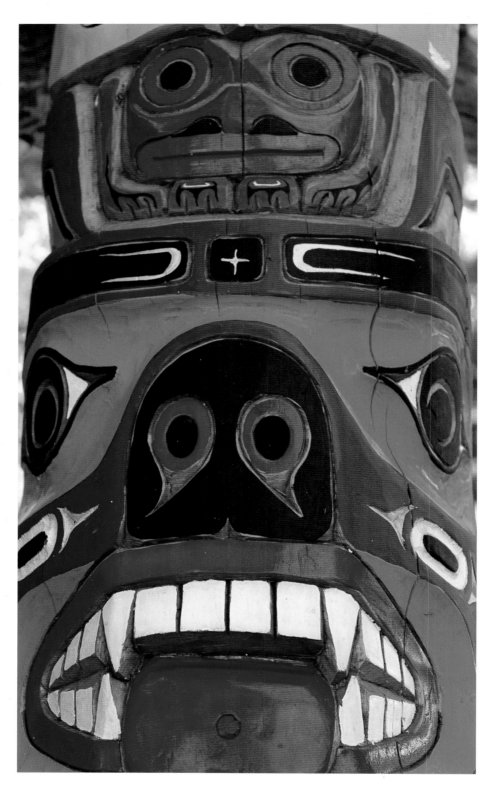

The photos on the previous two pages and on these pages all show
bears carved on different poles. The animal is the same, but all four
have been painted differently. On the next page, you'll see a bear
that hasn't been painted at all.

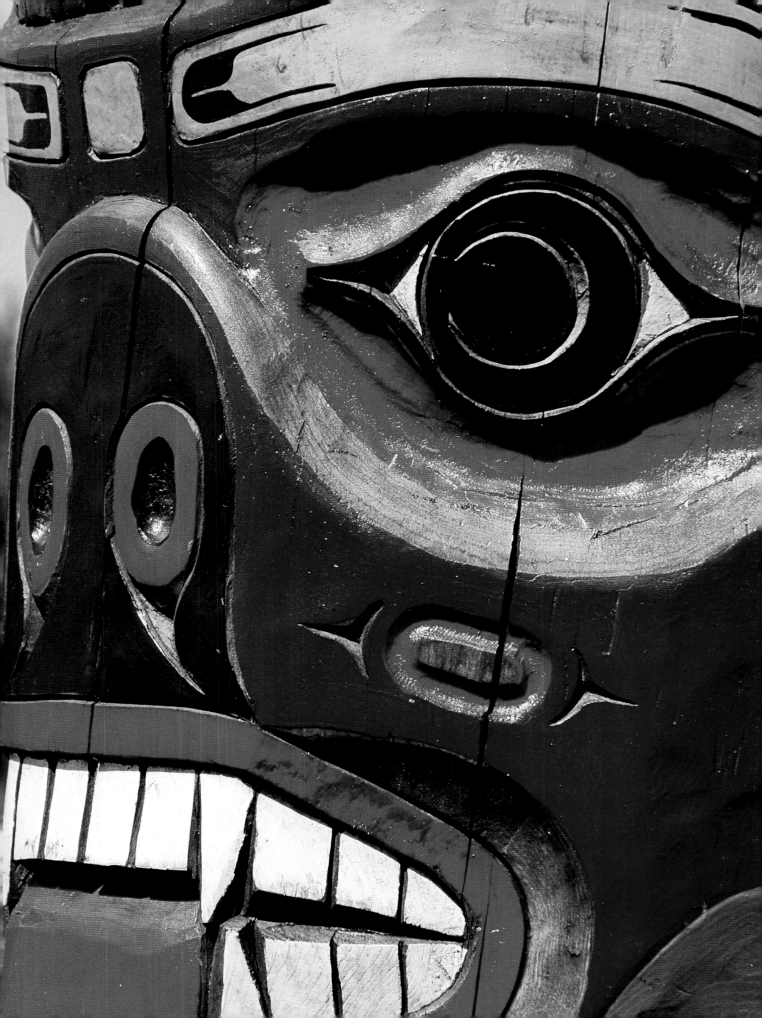

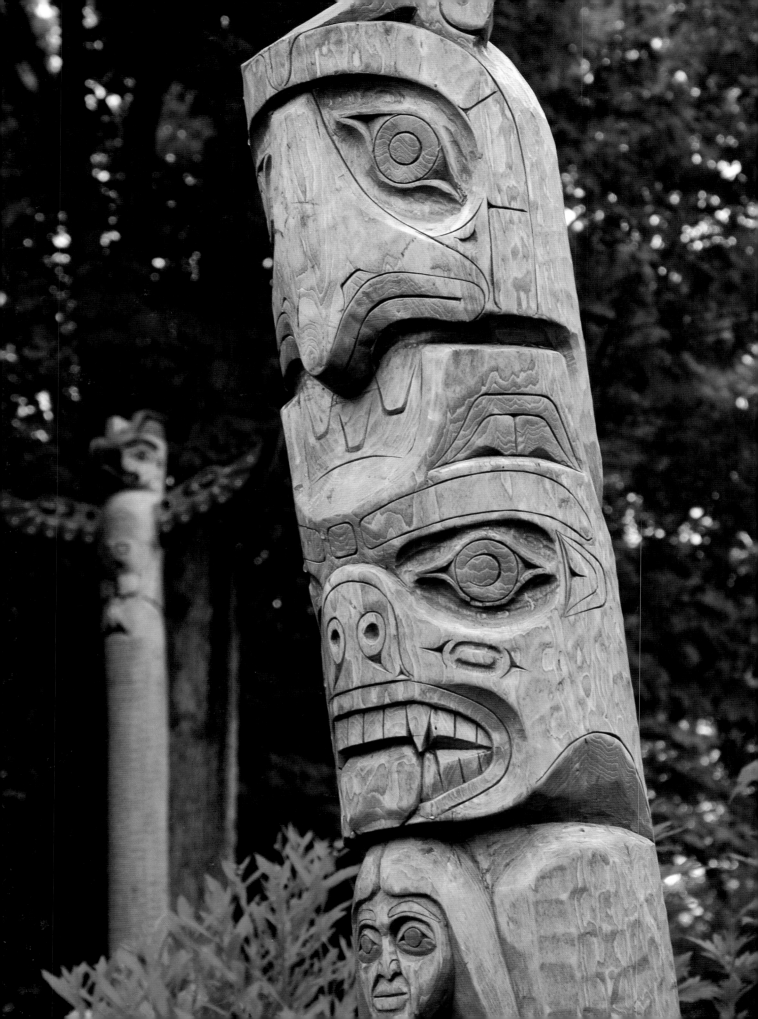

CHOOSING YOUR PAINTS

Any number of paints can be used on poles, but the one we use most often is paint designed to cover steel. We have used Tremclad flat black on more than three hundred totem poles, and the paints are still crisp after fifteen years. The basic Tremclad palatte is available in any hardware store, but you don't need to be limited to their colors: the paint is oil based, so it will blend with any artists' oils sold in tubes at art supply shops. Tremclad red, for example, is best suited to painting fire engines, not totem poles. *Haida Red* has a bit more orange in it and is easily obtained by blending paints. However, if you like the fire-engine red, by all means use it. After all, it's your creation.

We use a lot of red, black, white, and green on our poles, as well as some yellow and blue. The green we prefer is a rich aquamarine tint, while our preferred blue is indigo.

Where these colors are used is determined, to some extent, by the nature of the subject you've carved. If we've carved a sun, we paint it yellow. You may prefer to paint your sun blue or green or red, but be prepared to have people ask you why. White is useful for painting filler areas on salmon heads, eyes, and ears. It provides contrast to the black sections and can help break up an area that would otherwise look too heavy. Blue is useful for the irises of eyes and to pick out dashing, cross-hatching, split Us, and secondary areas with S forms.

This is just a guide, though. There are few rules in the area of coloring a pole – or rather, the rules vary from carver to carver and from tribe to tribe. Unless you're trying to emulate a particular style, it's best to follow your own feelings in this matter. Study other carvers' poles; look at how they use color in various ways. Think of how you used color in your two-dimensional works. If you're still not sure, go back to your initial sketch and make a few photocopies. Try coloring them in different ways, and see what you like.

Once again, the bear is used in the totem pole to the left, this time using stain only.

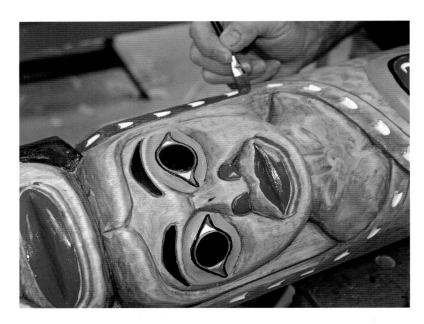

BRUSHES

You'll need a variety of different sizes of brushes to paint your work. As your work progresses, you'll find rigger brushes to be particularly useful. Available from art supply stores, these brushes have long bristles, usually three times the length of regular brushes. Their name comes from the days when artists often painted scenes of ships at sea and needed to be able to paint the long lines of rigging in a single brush stroke. With their long bristles, rigger brushes can hold a great deal of paint, making them ideal for that work.

That same quality makes them invaluable in West Coast painting as well. Many ovoids have a single line just inside the primary formline. It is quite difficult to follow this line without using a rigger brush. They are sold in various sizes – a #2 and a #4 will be great assets.

To keep your brushes in good shape, you need to care for them. Clean them thoroughly, and rinse them in thinner when you're done. Then dip them in clean automotive oil, like 10W-30, and stand them with the bristles up. Cared for this way, a good brush will serve us for over a year of regular use.

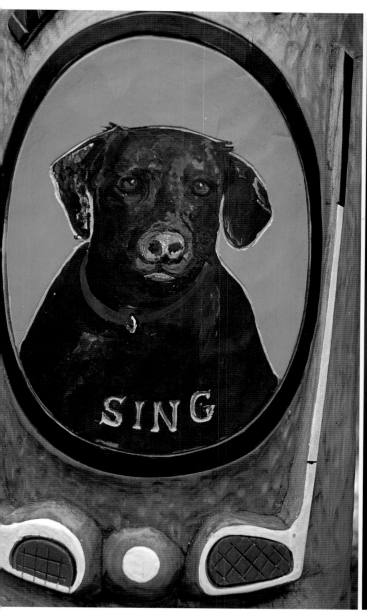

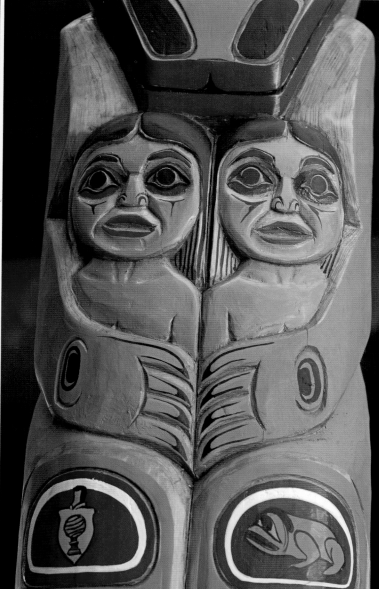

Some poles are completely painted, while on others paint is used only to highlight elements such as the eyes or lips (right). Occasionally a pole will have an element that is completely painted on, such as the illustrations on the knees (top right) or a portrait of a beloved pet (above).

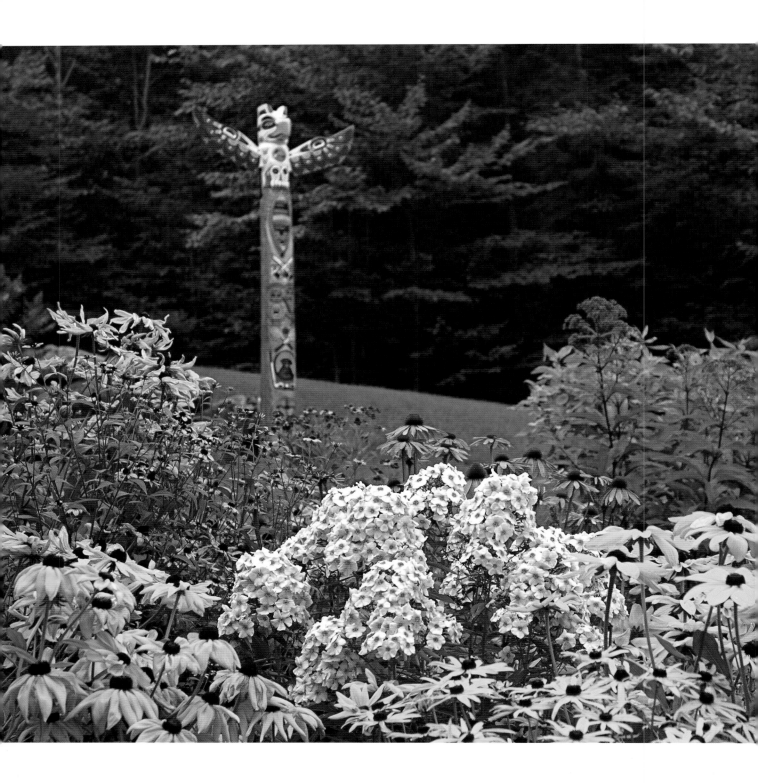

Poles look terrific in the garden, but be sure to keep plants away from them. Wet plant leaves pressed up against a pole will transfer dirt and moisture, and accelerate the rot.

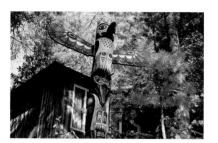

Placing your pole

Congratulations! You've just finished carving your first pole. If you're anything like us, you can't wait to get started on the next one in order to carve all the ideas you couldn't fit into a single pole. But first you want to get this new creation of yours standing upright and on display where you and your family can admire it. But where to put it?

West Coast carvings were sometimes placed outdoors, sometimes indoors. You can do the same. If you're placing a pole outdoors, you need to think about how the weather will affect your creation. First of all, you need to accept that dirt will rot your pole just as it has rotted many traditional poles that once stood on the West Coast. Remember that hole you drilled in the pole, back at the beginning of this journey? This is where it comes into play. From a building supply store buy a length of steel rod, you will be able to insert into the base of the pole. This gives you a support that you can fasten into a base.

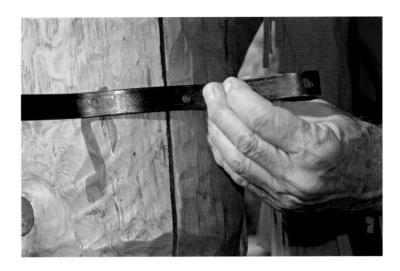

The base you use depends on your setting, but for a pole that will last for generations, there's nothing that can beat cement. If you're absolutely certain you know where the pole is to go, pour a cement pad and insert the steel rod. Use a level to ensure the rod is absolutely and perfectly plumb. Steel rod can be bent slightly to make the pole stand straight, but it's always better if you don't have to do that.

Let the cement cure for at least five days to ensure it's at its maximum strength. Then enlist a friend to help lift the pole and slide it onto the rod.

If you're not entirely sure where you want the pole to go, it's not hard to make a temporary outdoor stand. Buy a 2-foot by 2-foot patio stone, and drill a hole in it using a masonry drill bit that's slightly larger than your steel rod. Place the patio stone where you want the pole to be, and put the rod in the hole. Holding it as plumb as you can, drive it a few feet into the ground, leaving about a foot sticking up above the patio stone. This will hold an 8- or 9-foot pole quite well but is not hard to move.

Poles look terrific in the garden, but be sure to keep plants away from them. Wet plant leaves pressed up against a pole will transfer dirt and moisture, and accelerate the rot.

If you're putting up a pole in a particularly windy area, you might want to add a reinforcing rod at the back. We use 6 to 8 feet of 3/4-inch steel rod. Ask a welding shop to fasten steel brackets every 2 feet along the rod. Set the reinforcing rod into your base, and drive 3-inch #10 wood screws through the brackets into the pole.

A pole that stands outdoors should be treated with preservative every year. Just paint on a coat of Cetol, and wipe it off again. Be particularly careful to wipe the preservative from painted areas of the pole, as it can add a yellowish color.

If you live in an area that experiences snowy winters, you may want to consider moving your pole indoors for the winter. The winter won't do your pole any good, and if you're placing the pole in the garden or at the cottage, you may not be enjoying it anyway. Why not lengthen its life by bringing it indoors? You can put it in storage or, better yet, move it onto an indoor base and let it form part of your interior winter décor.

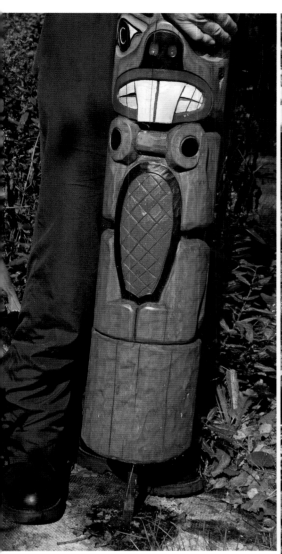

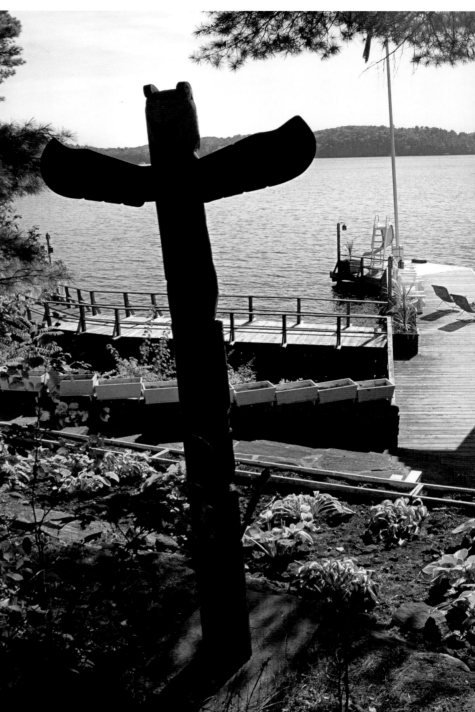

If you're putting up a pole in a particularly windy area, you might want to add a reinforcing rod at the back.

Top – From a building supply store buy a length of steel rod, that you will be able to insert into the base of the pole. This gives you a support that you can fasten into a base.

Left – A simple steel bracket can be fastened to the back of a pole intended for indoor use.

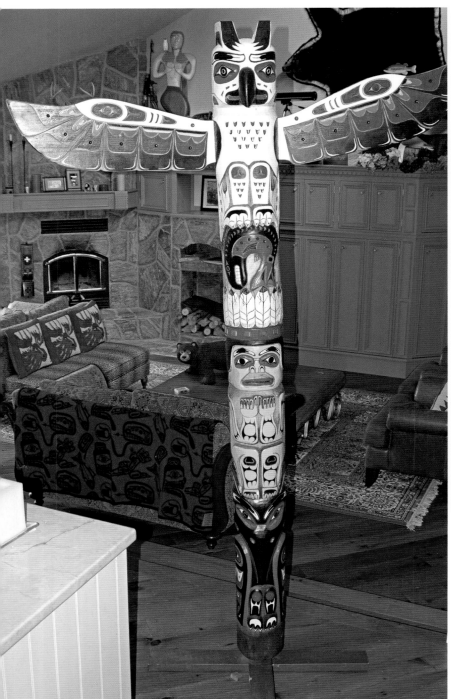

The best base for a freestanding pole is a slab of pine log. You can also make a perfectly good base from crossed pieces of two-by-four lumber. Fasten scrap carpet to the bottom of your base, so it can be moved without marring the floor.

Bend two brackets that are slightly wider than your pole, and fasten them to the back of the pole – top and bottom – with a pair of #8 wood screws. The brackets should hold the pole a couple of inches out from the wall.

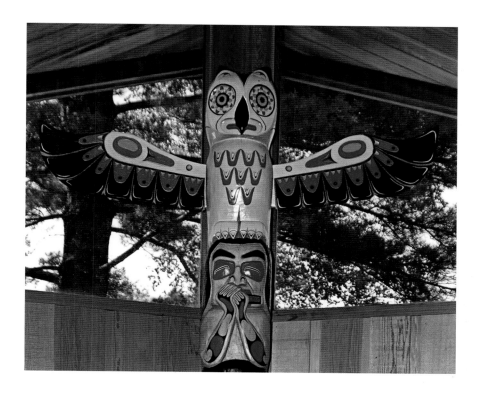

INDOOR MOUNTING

A big indoor pole can make a dramatic statement in a grand home, while a small one can sit discreetly in the corner of an apartment. It's entirely up to you. If the pole is to be freestanding, the kind of base can be as elaborate as you want – if you've got a rockery in the middle of your great room and want to use a granite boulder as a base, go right ahead. It will look fantastic. A more modest option for a free-standing support is to buy a slab of pine log from a sawmill or logger. You want something at least 16 inches in diameter and a foot or more thick. Drill a hole in the middle of it at least 10 inches deep, insert your steel rod, and you're ready to mount the totem pole.

Before you mount the pole, though, it's a good idea to cut a piece of scrap carpet slightly smaller than the pine slab and glue it to the bottom. This makes it easier to move the pole without scratching floors or pulling carpets.

If a pole is to be standing against a wall, the best way to display it is to purchase a length of 3/4 inch by 3/16 inch flat iron or aluminum from your local hardware store. Bend it into two brackets that are slightly wider than your pole, and fasten them to the back of the pole – top and bottom – with a pair of #8 wood screws. The brackets should hold the pole a couple of inches out from the wall, as it will have a much more dramatic effect that way. They can be painted black, or else painted to match the walls.

Before mounting the pole, cut a piece of scrap carpet slightly smaller than the base and glue it to the bottom.

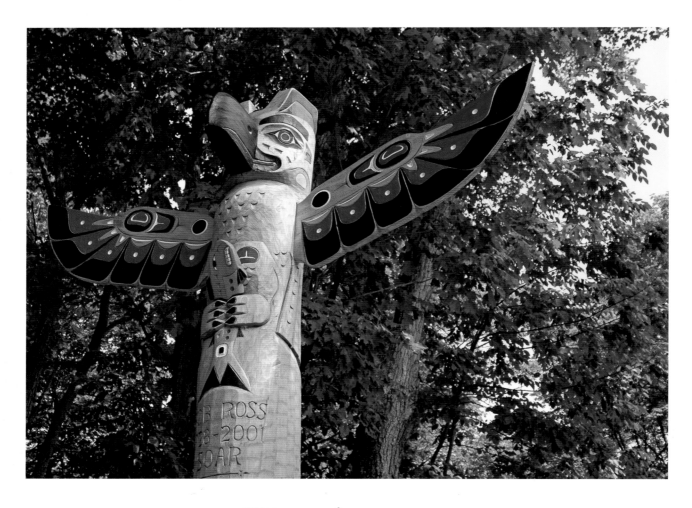

WHAT'S NEXT

Now that you've carved one pole, chances are pretty good you'll want to carve another. You could try a welcome figure, a pole featuring a single human figure. Traditionally erected at the edge of the water to welcome visitors arriving by canoe, they can also be placed at the end of the driveway. You could carve another totem pole that tells the story of another family member, or make a single figure that's designed to hide in a corner of the garden and surprise and delight visitors. There are many ways to use West Coast art forms. You now have the skills, so go ahead. Use your imagination, and carve.

Right – A student carver's first pole sits proudly in the garden. Many novices find that the first pole is just the beginning of their carving careers.

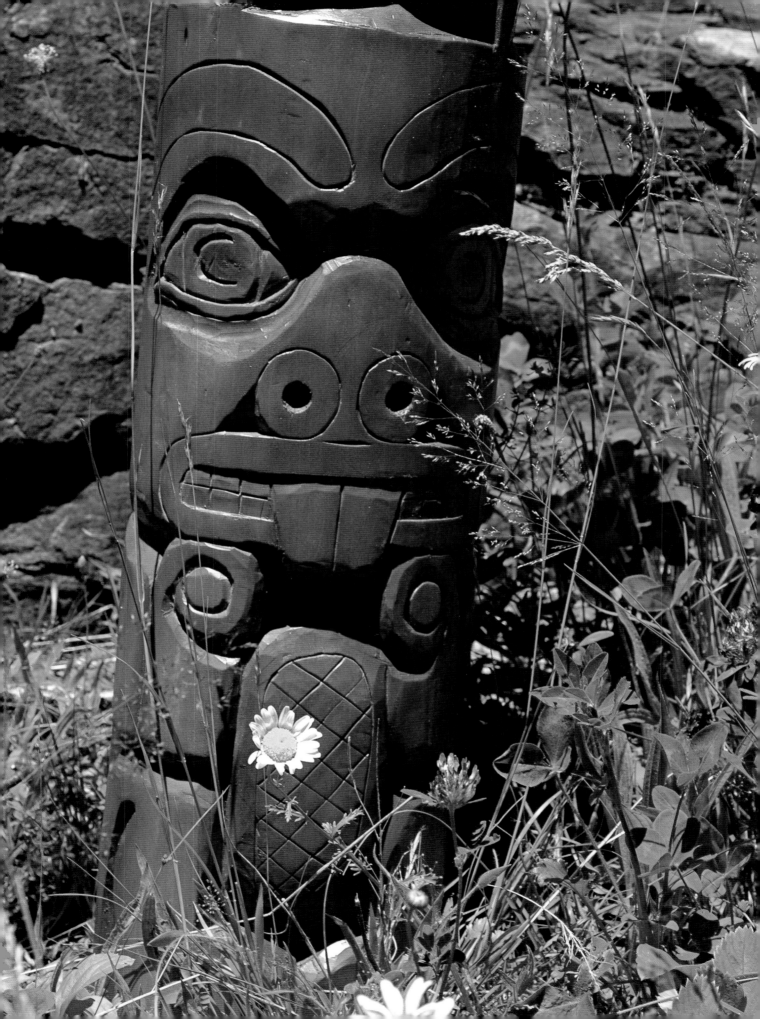

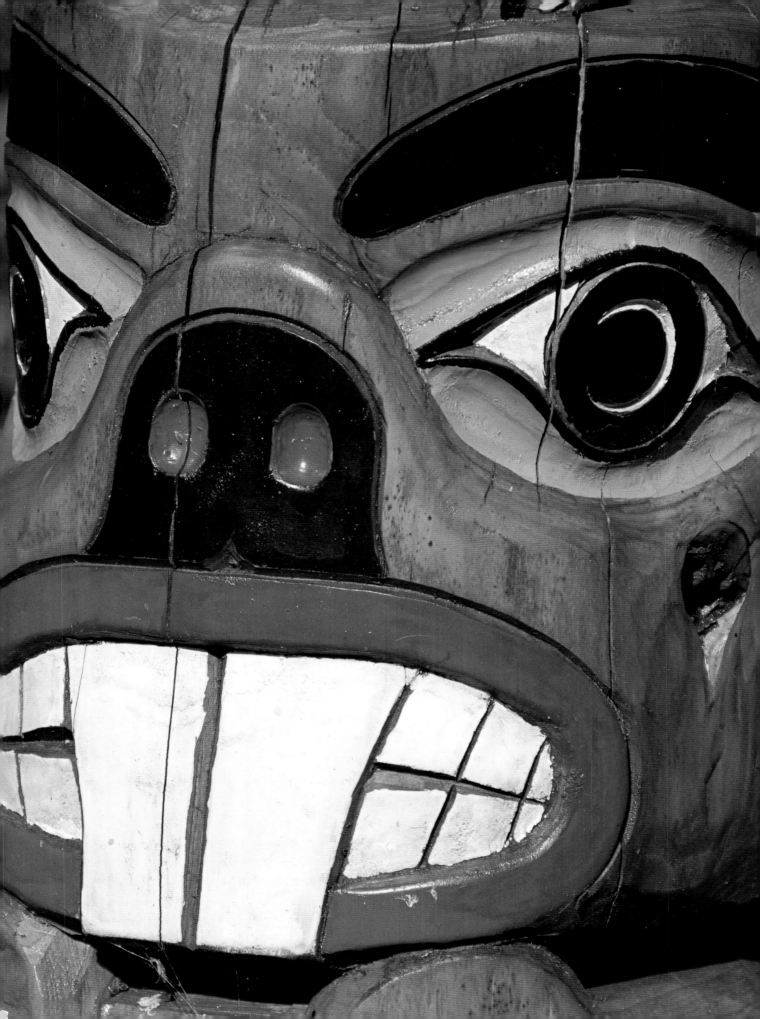

Symbols of the West Coast

Totem poles are rich in symbolism, containing many different elements that convey meaning to the viewer or the carver. The exact meaning behind many of the older poles has been lost, but the broader meaning of some symbols has been passed down through generations of carvers.
Here is a partial list of some creatures that are used in West Coast art and the attributes they are intended to convey. You may wish to draw on some of these as you design your own works of art.

Bear: strength, humility, and respect.

Beaver: hard work, teaching, survival, and wisdom.

Bluebird: modesty, confidence, and happiness.

Blue jay: the proper use of power.

Buffalo: abundance, prayer, healing, and good fortune.

Bumble bee: honesty, future success, hard work, and community-mindedness.

Butterfly: transformation, the courage to change, balance, and grace.

Canary: power of song and voice.

Cardinal: vitality and persistence.

Cat: grace, sensuality, and psychic vision.

Chicken: fertility and sacrifice.

Cock: sensuality and optimism.

Cougar: balanced leadership, cunning, and wit.

Coyote: rumors, tricks, and adaptability.

Crane: longevity and powerful feminine energies.

Crow: magical and spiritual strength.

Deer: gentleness, sensitivity, alertness, and peace.

Dogfish: menace, fear, persistence, strength, and leadership.

Dolphin: harmony, love, and wisdom.

Dove: peace, maternity, and promise for the future.

Dragonfly: ever-changing life.

Duck: comfort and protection.

Eagle: healing strength, power, wisdom, cunning, and new vision.

Eagle feather: good luck.

Frog: healing powers and extremely good luck (in the tradition of the Tlingit people of Alaska).

Halibut: life protection, strength, stability, the spirit undergoing a change in life.

Hawk: great eyesight, hunting skill, outstanding power, and truth.

Heron: aggressive self-determination, self-reliance, and patience in achieving goals.

Hummingbird: love, beauty, intelligence, boundless energy, and impossible agility.

Killer whale or Whale: the traveler and good luck.

Kingfisher: new warmth, sunshine, prosperity, speed, agility, and fierce defense of home.

Lightning snake: an ally of the thunderbird capable of throwing lightning.

Loon: peace, tranquility, and generosity.

Meadowlark: intuition.

Mockingbird: the ability to recognize innate skills.

Moon: the guardian and protector of earth at night, and ability to change moods.

Nuthatch: understanding of spirit within the physical state.

Oriole: opening new doors to new relationships.

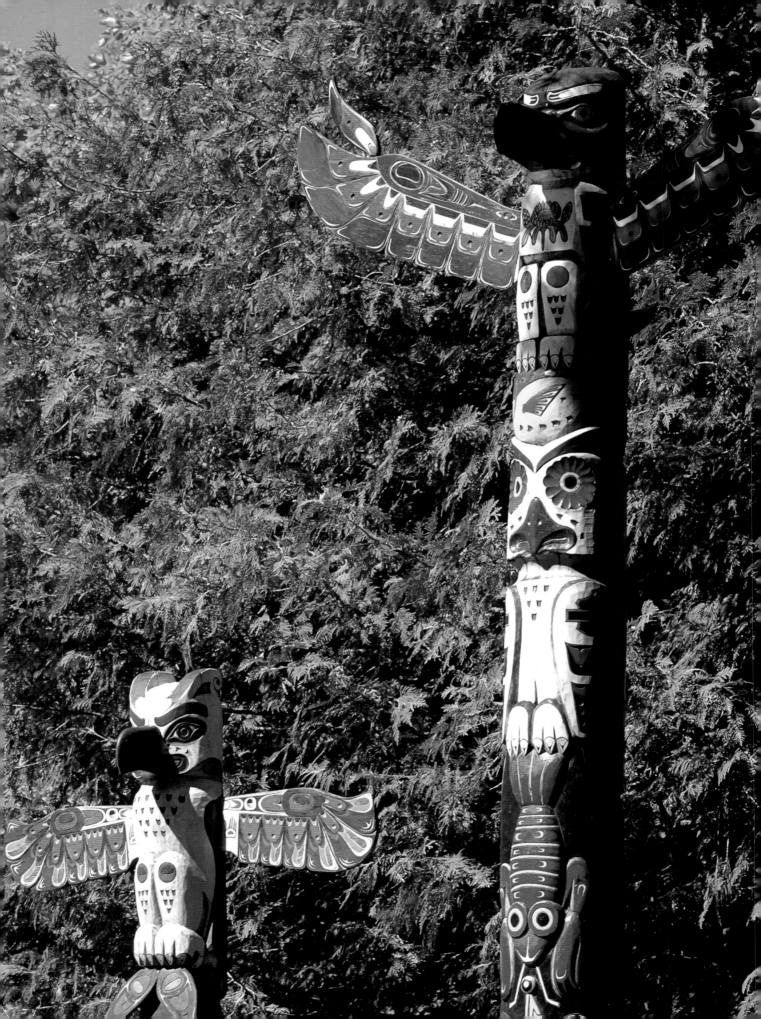

 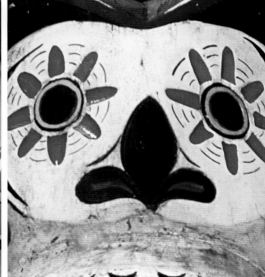

Otter: trust, curiosity, lasting and loyal friendship, and a balance of play and work.

Owl: magic, silent wisdom, femininity, and light.

Parrot: color healing, and the power of lights and colors.

Pelican: renewed buoyancy, unselfishness, and not being overcome by emotion.

Pheasant: family, fertility, and sexuality.

Pigeon: security of home, return of life, and very gentle, loving energy.

Quail: group nourishment.

Raven: the creator of the world; represents creativity, knowledge, and the supernatural power to transform into anything.

Robin: new growth in a variety of areas of life.

Salmon: power of life force to humans and animals, and rebirth.

Sparrow: awakening and triumph of common nobility.

Sun: the provider of healing energy, and a relationship with inner beauty.

Thunderbird: the most powerful of spirits, capable of carrying off killer whales; represents power and good luck.

Wolf: strength through endurance, supernatural cunning, and sense of family.

This is your starting point. Remember that in creating your art, you can fill it with valuable things in your life.

Many of the totem poles from the nineteenth century cannot be completely interpreted as the carver was told by the chief to represent parts of his life that were important. Since both the chief and carver are long gone, the mystery remains.

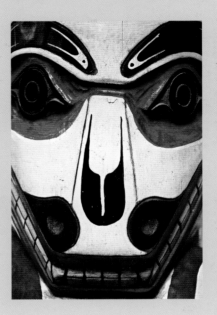

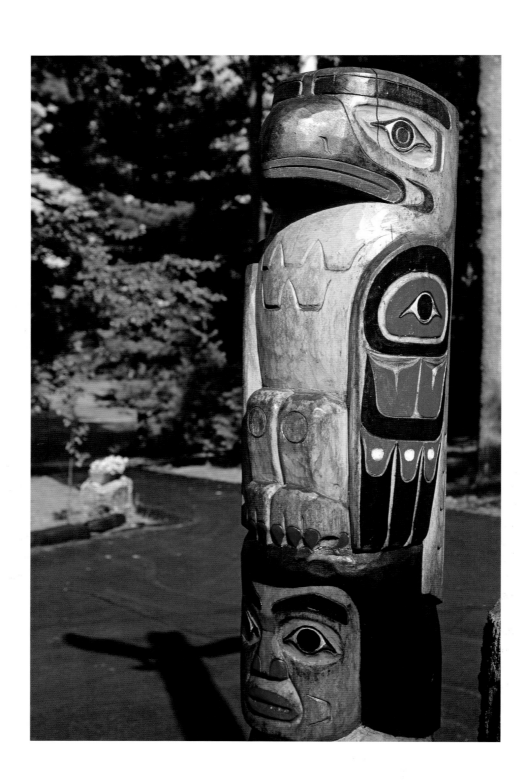

ABOUT THE AUTHORS

Wayne Hill carved his first totem pole as the result of a challenge from his old friend Jimi McKee. Since that time, the two men have created more than three hundred totem carvings for villages, towns, cities, businesses, corporations, families, and individuals. For the past five years, Hill has taught a summer course on totem pole carving at Sir Sandford Fleming College. He lives in Gravenhurst, Ontario.

James (Jimi) Alexander McKee's passion for West Coast art led him to purchase and study a collection of 218 totem poles by master carvers from British Columbia. He spent several years analyzing the shapes and tensions in Western carvings, along with proper carving and painting styles of nineteenth-century artists, before attempting his own work. McKee has also produced a collection of log furniture, tables, bowls, fish, and paddles with the central West Coast art motifs. He divides his time between Orillia, Ontario, and Big Pine Key, Florida.

Bev McMullen is the recipient of a Prime Minister's Award, a Nikon Wildlife Award and a Kodak Nature and Islands Magazine Award. She has photographed extensively in the United States, Canada, South America, Europe, Africa, and Australia. Her work has been featured in numerous books, magazines, newspapers, and calendars. She lives in Bracebridge, Ontario.